a wife's
40-day
Fasting
& Prayer
journal

a wife's 40-day Fasting & Prayer journal

a guide to strategic prayer

Kaylene Yoder

HUMBLE
WISE
PRESS

Dedication

For my Sam,

the one my soul loves.

—Song of Solomon 3:4

Testimonials

"One blog I am impressed with lately is by Kaylene Yoder (kayleneyoder.com), who, with her husband and young family, left her Amish community for evangelicalism. Her resources include 40 Prayers to Pray Over Your Husband – *fantastically convicting and biblical prayers that are equally relevant to pray for oneself* as [for] one's husband – and, most impressively a guide to fasting for wives. What strikes me is that she encourages wives not to identify primarily with their husband's spiritual lives, but to become real prayer warriors in their own right – which will, of course benefit their own husbands greatly!"

—**Dayspring MacLeod, originally published in The Record, May 2016**

"There are a lot of resources out there for marriages, yet this is one of the few that invites me to participate. I actually have an active role to play and it's geared toward changing me as a wife, not changing him as a husband. Not only that but *it draws me to the heart of God first – my own walk and desire is transformed and that, in turn, transforms how I relate to my husband.* Throughout the entire exercise, Kaylene's gentle spirit and her passion to see God's glory made manifest in healthy marriages is incredibly encouraging. She puts gracious words to the many scenarios which produce friction and redemption in marriage. I simply love her style of boldness and grace to speak truth and encourage growth. *This is absolutely a resource worth keeping and re-visiting frequently throughout marriage.*"

—**Holly Brown, founder and author at The Brown Tribe**
www.thebrowntribe.net

"Being married almost 2 decades, I can attest to the power of prayer in marriage. *Prayer has strengthened my marriage; in fact, it was my most effective tool for my husband coming to faith.* It is prayer that changes my heart when there is a disagreement my marriage. My hardened heart quickly softens towards my man when I pray through my frustration and anger. I have also witnessed changes in him when I turn to prayer instead of nagging. I absolutely love that Kaylene focuses intently on the importance of prayer in marriage. She leads us wives in praying for our men in 40 different ways: his work, his heart, his faithfulness, his attitude... our husbands need prayer covering from their wives in all of these aspects. *Whether you*

already pray over your husband or not, A Wife's 40-Day Fasting and Prayer Journal, will help you focus on this vital responsibility in marriage. Start praying for your man and your marriage...then watch God work and move in your life."

—Aimee Imbeau, founder and author at A Work of Grace
www.aimeeimbeau.com

"*I honestly wasn't sure what to expect from A Wife's 40-Day Fasting and Prayer Journal.* Based on the title, I thought it would probably require some prayer and fasting. However, I wasn't expecting the author to bring up so many areas of my husband's life that I hadn't considered praying about before. Neither did I expect her to address my own heart in such a challenging manner. However, *what really sold me on the idea was the interactive nature of the journal, where a wife can dig into the Word of God for herself and let it speak!*"

—Jen Stults, founder and author at Being Confident of This
www.beingconfidentofthis.com

"Thank you so much for allowing God to use you. I have enjoyed this journey and I look forward to doing it again and again and again. I was desperate for a reconciled relationship with God while *going through a rough time in my marriage that almost ended in divorce, and two days into your fast God moved and allowed us to reconsider*. Thank you for being such a blessing to many."

—LaShunda Felton

"As the owner of over 100 books on fasting, I must say yours is *exceptional!*"

—Dian VonWetzel

"This 40-day prayer challenge was *an eye opener as to how much my husband struggles with things in his heart that he never talks about!* Thank you so much for sharing! God bless you!"

—Amanda

Contents

Introduction

When I first started fasting for our marriage, I did so with the attitude, *that man has to change!* I was sure fasting was the magic wand that I could give a few flips and flings to and things would all straighten out.

I mean, the intent and promise for our fasting is to *"to loose the chains of injustice and untie the cords of the yoke…Then your light will break forth like the dawn, and your healing will quickly appear"* (Isaiah 58:6,8). What a great promise! And I wanted a piece of it.

Rewind a few years. The enemy had successfully sabotaged much of both our lives. Our marriage was painful, full of shattered dreams. My health was sliding downhill, and my faith was right behind it. I was in a desperate place. I longed for comfort and hope. The isolation, anger, disappointments, loneliness, and defeat were becoming too much.

I cried a lot. I prayed a little, not knowing if it was actually helping and wondering if there really was a God who gave two cents about me, where in the world was He and why didn't He show up? I screamed on inside at everything and on the outside at nothing.

My breaking point came one night as the brands of icy heartache once again pressed so deep I found it hard to breathe. Blinded by desperation for the healing of a painful marriage, I had it out with God. Barefooted, I ran for miles on gravel; I threw rocks at His sky, yelled, and when finally exhausted, I sat in His dirt refusing to move until He brought me some kind of relief. I didn't know what that relief looked like or whether it would come. Little did I care if it didn't as long as He would end the hurt and take me home with Him.

Yes, that was my prayer. Relieve me, or kill me. It was an Elisha moment from

1 Kings 19:4. But when my anger, frustration, and emotions were spent, and I was physically exhausted, the Lord surrounded me in ways only He can.

No words were spoken audibly, but I heard Him loud and clear. No touch that could be felt, but I knew I was being held. He comforted me, He quieted me with His love, and He gave me strength to simply breathe. There in the depths of anguish, the Comforter, Peace-bringer, Mighty God, Everlasting Father, Great Shepherd brought me to that comfort and rest that doesn't make sense.

There, nestled in the sacred ground beneath the wings of the One who loves you and me more than we can fathom, this book was born. There with the Lord, the stars, and the crickets, I knew I was called to do the greatest battle of my life- the battle for my marriage.

And it was going to be brutal. I was assured of that.

But it was going to be beautiful. I was even more assured of that.

The days, months, and years following have been harsh. Many times I've felt my will to keep pressing on falter. Many days my faith has been weak. Many days I would have preferred to curl up and let death set me free.

There are still days the enemy brings back past pains with such force it almost takes my breath away and leaves me whirling. However, the Lord hasn't brought us this far to let us become a statistic – of that, I am convinced. Greater is He who lives in us than he who lives in the world. We are made to conquer in the Lord, and when we bring all our brokenness to Him and dump it at His feet, He promises to care for us, fight for us, relieve us, nourish us, and carry us through. He doesn't mind if our anger, frustrations, pain, shame, distrust, and all manner of emotional breakdowns get unloaded on Him by the garbage truck full. He doesn't mind how bad it smells; He doesn't even mind if we do it in an undignified manner. He just desires that we bring it to Him. When we do, He proves His faithfulness. He proves Himself trustworthy. Faith is renewed, His power displayed, and His glory undeniable.

Dear friend, I don't know why you picked up this book. Maybe you are sitting in the unforgiving soil of a hard season. Maybe you are ready to make a run for it, ready to bolt, disappear, and never look back. Maybe you've grown distant and lonely in your marriage. Maybe you don't care whether your marriage is revived or not.

Maybe this fasting and prayer idea is your last resort.

If so, you are in good company. These next forty days have the capacity to change

your marriage forever. The question remains: are you willing to go the distance? Are you ready to be molded, shaped and loved like never before?

Even though your answer may be a tentative 'yes,' I pray you will commit to taking just one day at a time. Keep in mind that Ephesians 6:10-18 tells us our battle is not with flesh and blood, but rather with the powers and principalities of darkness.

Our battle is with the enemy of our soul, not our husband. Our battlefield has greater proportions than just our marriage. The ultimate battle is for our faith. And if the enemy thinks he can get to our faith by attacking our marriage, you can put money on the fact that he is going to try it.

Stand strong, girlfriend.

By the end of this book, you will be glad you ran the race. You'll be better equipped to continue fighting the good fight. You'll be laser-focused on where your real battles are and Who to engage to fight for you. I pray you will not put this book on the shelf and forget about it. I pray this very book in your hands becomes rag-tag, written in, tear-stained, taped up, and tied together to keep it in place, not because of something I've written, but because of how the Lord moves you to greater dependency on Him and pulls you to greater intimacy and trust in Him.

I pray He continues to use this book over the many years of your marriage to snap the chains of oppression and untie the twines of sin. I pray that through consistent prayer and petition, the Lord will continue to satisfy your needs and soothe your pain just as He promises.

I believe when we call on Him, He will answer. I believe that He will always guide us and satisfy our needs in the deserts of life, that He will strengthen us, and as the Restorer of Broken Walls, will redeem the ruins of our lives and make them like well-watered gardens (Isaiah 58:6-11).

I don't know about you, but I could use a whole lot more of that.

So, join me. Let's do life from our knees for a while. Let's invite the mighty hand of God to sweep through our hearts, homes, and lives like never before, breaking through the walls, awakening our souls, cleansing our minds, ridding us of our self, then infusing us with Himself as He restores us for His glory. It's time to stake a few claims and retrieve the ground the enemy has stolen from our lives and our marriages.

Let's go, warrior friend!

Please consult with your health care provider before fasting.

How to Use this Book

Aregular question I get is, "Am I fasting properly? How do I know I'm doing it right?" In biblical times, fasting was associated with tearing clothes, putting on sackcloth and sitting in ashes. However, today we have Matthew 6:16-18 to tell us that we shouldn't make a show of our fasting. Rather, we should do it discreetly, keeping it a personal experience between us and God. This adds greater intimacy and deepens our faith and trust.

Traditionally, fasting means removing all food for a period of time. While this is still the recommended way of fasting, there are also other ways to apply the fasting spiritual discipline. In this book you will find six ways to fast:

- Fast one meal.
- Fast all beverages excluding water.
- Fast from television, electronics and social media.
- Fast all sugary foods and drinks.
- Fast all meats.
- Fast all solid foods.

Each day you will be given one of these fasting options. You may choose to follow the guide or you may choose your own fast depending on your health needs and abilities.* Whichever fast you choose, the ultimate goal is to create a space, an open time slot, a need or a craving to consciously remind us to call on God and trust Him to fill in that space. *God is more concerned about our heart attitudes and intentions than He is about what we sacrifice during a fast.*

This book is designed to provide a personal fasting and prayer experience. However, you may want to journey through these forty days with a friend or a Bible study group. Having a friend to encourage and pray with is great accountability and very enriching.

Blessings to you and your marriage, praying friend!

Please consult with your health care provider before fasting.

Day 1

Praying for You, His Wife

Quite frankly, this submission thing stinks sometimes. As I hacked away at this wife thing, I came up shorthanded, frustrated, and teary eyed almost every single time. I knew if I was going to thrive in God's design for marriage, I would need some kind of help — no, more than help, a divine intervention — because I am certainly not strong enough to go the distance in any spiritual battle. I've tried that. I didn't hold out very well.

So I dug into God's Word and He led me to three verses that gave me a starting point. The first one I didn't like much because it talked about submission. The second one meant replacing my mindsets and thought processes. However, by the third one I knew what I needed to do to make it through the first two.

1. *"Wives, in the same way be submissive to your husbands so that, if any of them do not believe the word, they may be won over without words by the behavior of their wives, when they see the purity and reverence of their lives." — 1 Peter 3:1-2*

It's easy to overlook the second part of this passage; the part that gives a practical reason for a pure and honorable life. Whether we are in an unequally yoked marriage, our husband has fallen complacent, or we just have a hard time seeing things the way he does, this verse tells us that our behavior, attitudes, and actions, have a huge impact on our husbands.

Remaining pleasant when we are faced with unkindness is very hard, yet a wise, godly woman knows she is responsible for her own responses and does not base them solely on someone else's actions. Asking the Lord to infuse us with strength and wisdom for tense moments will help us respond in more appropriate ways, giving all those around us a pleasant example of Christ. Living in His power is never about "putting up with" things or "faking it 'till we make it." It's about being a visible, touchable example of how Jesus would respond in tough situations.

2. *"Since, then, you have been raised with Christ, set your minds on things above, where Christ is seated at the right hand of God. Set your minds on things above, not on earthly things."* — *Colossians 3:1-2*

Becoming a wife who lived from a state of grace meant I had to retrain my thought processes. I had to let go of the old mindsets and claim the new. This became possible when I intentionally guided my thoughts to focus on the things mentioned in Philippians 4:8 – anything right, true and praiseworthy. But, more than that, I denounced anything that did not fall in those categories.

The enemy is a mastermind at setting little traps to get us to stray into foul territory. We must *"set [our] minds in things above"* so we can better recognize what is not from God. Placing our hearts and minds in the Lord's care and direction will teach us to more fully trust Him as the Umpire of our lives.

3. *"Then Jesus told his disciples a parable to show them that they should always pray and not give up."* — *Luke 18:1*

This parable was about a woman who relentlessly brought her case before the judge. God Himself told us a story to encourage and instruct us to faithfully and repeatedly bring our cases before Him. He wants us to be adamant and specific in our requests.

As much as His love wants to fix it all right away, He also walks us through times of dry, desert-like seasons so we can be taught more about Him. The Israelites, for instance, wandered the desert for forty years, not because the Lord couldn't take them straight from point 'a' to point 'b', but because He had a few things He wanted to teach them about Himself. He wanted to cultivate trust and relationship with these people who were still held captive in mindsets of lack and slavery.

In the same way, He longs to set us free from our most painful things, yet He wants to be known as more than a wish granter. He wants us to know Him as the Slave-freer who holds our hands and walks with us in the trenches – personal, present, dependable. So, He invites us to bring our cares to Him repeatedly with all the hope of childlike expectancy.

Therefore, let's not grow weary of hearing our knees hit the floorboards. Let's pray for ourselves to be made new in heart and mind, invite the Lord to walk with us, and ask Him to infuse us with His character. Let's ask to be anointed with wisdom and doused with extra measures of grace. Let's pray until the calluses around our hearts are replaced with calluses on our knees because that's what He tells us to do – always pray and never give up.

Verses to Reflect Upon

*"A wife of noble character is her husband's crown,
but a disgraceful wife is like decay in his bones."*

Proverbs 12:4

*"I will give you a new heart and put a new spirit in you; I will remove from you
your heart of stone and give you a heart of flesh. And I will put my Spirit in you
and move you to follow my decrees and be careful to keep my laws."*

Ezekiel 36:26-27

Romans 12:9-10

Philippians 4:5-7

Ephesians 4:22-24

Father God, thank You for this man you have given me. Thank you for how far You have brought us. You have proven to be faithful. You have proven to be present. You have proven to be good, oh, so good. My heart overflows with praise and thanksgiving to You.

Reflecting on our marriage, I am convicted that I haven't always been the wife You designed me to be, nor the wife my husband needs. I confess the times I have been disrespectful in words, attitudes, and deeds. I see them as You do: sin. Remove any bitterness, selfishness, and impatience from my heart. In those places plant ready forgiveness, patience, and the willingness to bear all things.

Make me kind, Lord. Make me gentle. Make me good. Teach me Your ways. Transform my heart into a gentle, grace-extending one. Make me faithful, not only in body, but also in the way I speak and behave toward my husband.

Make me the kind of wife who will not do or say anything to degrade or devalue my husband, but one who is trustworthy. Renew my mind so I can judge my words and actions based on Your truth and not just by how I feel. Let my husband know that I will bring him good and not evil all the days of my life (Proverbs 31:11).

Father, I know my first and foremost ministry is to my husband. Remind me of this often throughout the day. Help me seek ways to bless my husband with my body, words, and actions. When words are inappropriate, guard my tongue. Help me discern and choose when to speak and when to remain quiet, pointing him to You through the purity and reverence of my life (1 Peter 3:1-2). Help me understand that sometimes my words are wrong no matter how right I am.

Transform me, Lord. Remind me not to expect my husband to fulfill me in ways only You can. Help me lay all my expectations at Your feet instead of his. Help me accept him the way he is and not try to change him into what I want him to be. At the same time, I release him to You to be molded, shaped, and grown into the man You created him to be: a man so much greater than I could ever hope to make him.

Father, work in me daily, that I might become the wife of my husband's dreams, one he can love easily, trust fully, laugh with, cry with, and grow old with. Give him a new wife, and let it be me. Oh, Lord, let it be me – completely transformed, fitting perfectly into the plan You have for his life and our marriage. Amen.

Specific Prayer, Praises and Convictions

Fasting Challenge

Fast one meal.

Record the meal:

Other fasting choice:

Day 2

Protecting Your Marriage

A marriage steeped in oneness and trust is the most beautiful replica of Christ and the church, and it is this mirror image of Jesus and His bride that the enemy hates so much. Since he cannot break Christ's devotion to the church, the enemy's next move is to wreak havoc on marriages in hopes to darken the beauty they represent. He pits spouses against each other by planting little seeds of irritation toward each other, which can blow up into World War III between the two.

However, we have an Ephesians 6 kind of armor that is designed to help us stand against the devil's schemes. We are encouraged to put on this heavy metal and use the attack plan found in verse 18 – prayer. Using the cross-hairs of prayer, we zero in on and disarm the enemy's plans to bring distance and divorce to our homes.

Lest we forget, God is on our side! He wants to see marriages lived out long and victoriously. He has eternal plans for the institution of marriage and what it represents, so it's no wonder the enemy hates it more and more. Another bitter heart from a broken marriage is just another trinket for him to wave mockingly in front of the Lord.

If you stand in need of healing for your marriage today, know that God's plans include those of redeeming and healing the smithereens of your once whole hearts. Using the battle plan of prayer, start taking back ground the enemy has taken. Pray for your marriage. Pray for your husband to lead well. Pray for yourself to come under his cover. Pray for strength and courage to forgive each other and grow together. Pray for healing and redemption. Your specific, relentless prayer is no match for the enemy, so stand strong and faithful in the Lord.

Using the following P.R.A.Y.E.R. acronym, we find six ways to strengthen our marriage. This can serve as a guide while praying as well as being healthy guidelines for marriage.

P – Pursue the Lord.

Matthew 6:33

R – Rid yourself of sin.

Ephesians 4:31-32

A – Accept responsibility for your actions.

Romans 12:3

Y – Yield your right to be right.

Ephesians 4:2-3

E – Encourage your spouse.

1 Thessalonians 5:11

R – Resolve to do the Lord's will.

Jeremiah 42:6

The most powerful super glue a marriage can have is to keep walking in love and dedication while going through the harder times; to still choose our spouse when we've experienced their worst, modeling the kind of love Christ has shown us. Pray for His Spirit to invade your marriage today.

Verses to Reflect Upon

*"Be devoted to one another in brotherly love.
Honor one another above yourselves."*

Romans 12:10

*"May the God who gives endurance and encouragement give you
a spirit of unity among yourselves as you follow Christ Jesus."*

Romans 15:5

*"Let us not become weary in doing good, for at the proper time
we will reap a harvest if we do not give up."*

Galatians 6:9

Prayer

Jesus, thank You for the perfect picture of marriage through Your relationship with the church. Help us replicate that model in ways glorifying to You. Teach us to love one another and "make every effort to do what leads to peace and to mutual edification" (Romans 14:19).

Father, don't let us grow apart or become comfortable in going our own ways, but bring unity between us so that we may be like-minded toward one another (Romans 15:5). I lift our marriage to You, asking that You refine us to be "perfectly united in mind and thought" (1 Corinthians 1:10).

Lord, I pray our commitment to You and to each other will grow stronger every day, binding together a tie that is not easily broken. Infuse us with the power of love in it's purest form. Teach us to be kind to one another, tenderhearted, forgiving one another, just as we are forgiven in Christ (Ephesians 4:32). Let us not grow weary of doing good to each other, so that at just the right time we may reap an abundant harvest (Galatians 6:9).

Lord, I pray You will protect us from anything that could harm or destroy our marriage. When trials persist, bring out of them a stronger marriage and faith. Let nothing come into our hearts, minds, and actions that could threaten our marriage. I take a stand against the enemy's schemes to divide us through lusts of the eyes and flesh. Open our discernment to recognize bitterness, jealousy, irritation, doubt, distrust or the like, and not let them grow into full blown division of our marriage.

Unite us, Father. Give us one mind and one spirit. Make our marriage a blessing to us. Help us find fulfillment, meaning, purpose, and growth in our commitment to each other. Protect us, Father. Preserve and strengthen our commitment to each other and You. In Jesus' name, Amen.

Specific Prayer, Praises and Convictions

Fasting Challenge

Fast all beverages excluding water.

Record the beverages:

Other fasting choice:

Day 3

Preparing for the Marriage Bed

Every once in a while I read something in the Bible that makes me want to throw a fit. First Corinthians 7:3-5 is one such passage:

> *"The wife's body does not belong to her alone*
> *but also to her husband.*
> *In the same way,*
> *the husband's body does not belong to him alone,*
> *but also to his wife.*
> *Do not deprive each other...*
> *so that Satan will not tempt you*
> *because of your lack of self-control."*

Uh-hem. **I barely made it past the first nine words of that scripture and I was a hot mess.** *"What do you mean my body doesn't belong to me? This is mine, and I will do with it what I want, thank you very much."*

However, the passage doesn't stop there, and after I had a moment to scrape my jaw off the floor, I read on to realize there is reason and insight for being diligent in sharing our bodies in the Marriage Bed. Depriving each other, or purposely withholding sex from each other, prepares a ground prime for the enemy's temptations to take root.

It is not wise to place your husband in the position where his sexual needs could cause him a lack of self-control. Ultimately he must decide for himself to stay pure before the Lord, however, a wife holds the power to help her husband maintain his integrity.

Applying the biblical concept of love, the kind that (1) honors others above itself, (2) lays down it's life for a friend, and (3) builds others up according to their needs, helps us discern wisely in how we honor God and our husbands with our bodies.

Here are a few practical tips that have helped me be prepared for when my husband reveals his desire in ways only a man can.

Prepare mentally. The largest sex organ is the brain. Try to be aware of his need. Calculate the frequency of his longings for you, and make pointed efforts to rest up or plan for those times. Being mentally prepared will help you respond more willingly and avoid making him feel as though he is intruding on you. Having a begrudging or reluctant attitude will take away the intended fulfillment and connection sex is designed to provide for both of you.

To help you prepare mentally try a few of these:

- Text him something flirty.
- Tuck a note in his briefcase or lunch.
- Look through a photo album together or recall a few favorite moments you've shared.
- Serve dinner in candlelight. Who cares if its mac-n-cheese and the kids are there? That's the stuff that makes lifetime memories!
- Think on a few good qualities about your husband. This will enhance your appreciation for him.

Prepare physically. Most women feel more confident when they are clean and dressed for the occasion. So, ask for ten minutes to prepare yourself for him. Take a shower; wear a little something (*or a little nothing!*) just for him. You will find it easier to relax and enjoy your Marriage Bed more. And your husband will be so thankful to unwrap the gift of you.

Prepare initiation. Often a husband feels insecure or inadequate in how to initiate his desire for his wife without feeling as though he is imposing on her. A wife can help alleviate this internal battle for him by occasionally initiating sex herself. And if you've been married for any length of time, you know it doesn't take long before your husband takes your sweet and flirty to some kind of fiery spice, so go flirt with him!

Pray for you and your husband to find time and energy for one another. Pray that you would find deepened intimacy and connection to each other that strengthens your marriage and understanding of each other.

Verses to Reflect Upon

*"Drink water from your own cistern, running water from your own well.
Should your springs overflow in the streets, your streams of water in public
squares? Let them be yours alone, never to be shared with strangers.
May your fountain be blessed, and may you rejoice with the wife of your youth.
A loving doe, a graceful deer – may her breasts satisfy you always, may you ever
be captivated by her love. Why be captivated, my son, by an adulteress?
Why embrace the bosom of another man's wife?"*

Proverbs 5:15-20

"Enjoy life with your wife, whom you love..."

Ecclesiastes 9:9

*"Marriage should be honored by all, and the marriage bed kept pure,
for God will judge the adulterer and all the sexually immoral."*

Hebrew 13:4

Song of Solomon 2:16

Song of Solomon 7:10

1 Corinthians 7:2-5

Prayer

ather God, thank you for this man You have blessed me with. I pray You would give him an increased sense of fulfillment in our physical time together, so that he might be encouraged to flourish in all areas of his life.

Father, You have designed my husband with a need for my body. Teach me how to give myself willingly and wholeheartedly. Remind me to plan and prepare for my husband so that I might not see his needs as obligations but rather as opportunities to love deeply. Let me find sex enjoyable and fulfilling.

I pray my husband will see my physical being as a gift and that he may be satisfied and captivated by my love (Proverbs 5:19). May our marriage bed be kept pure and honorable before You. May we not defile each others' bodies. Father, I stand against any temptations to partake in extra-marital affairs or adulterous thoughts. May our trust in each other never be broken or endangered by the schemes of the enemy or evil plans of others.

I pray, Father, that You will remove any remembrances or enticements of other intimate relationships we may have had prior to our commitments to one another. Purify our minds from any wanderings or longings of past relationships. Replace them with renewed rapture and devotion to each other. As we become one in the flesh, may we bring glory to You, the Author and Creator of intimacy. In Jesus name, Amen.

Specific Prayer, Praises and Convictions.

Fasting Challenge

Fast from all electronics.

Record them:

Other fasting choice:

Day 4

Guarding His Eyes

Up until the past few decades, the only scantily clad woman a man would see was his wife. Today, however, there is little discretion in our culture. Women dress provocatively in hopes to be noticed, and men notice because that's what they are hardwired to do.

So what chance does a Christ-loving, modesty-seeking wife have to catch her husband's eye? Furthermore, how can she help him overcome temptation?

Take a small walk in your man's shoes. He is strolling down the sidewalk and a hundred yards ahead he sees a woman in a tight mini skirt, plunging neckline and heels that make her frame sway back and forth in a most enticing way. At that point he must make a choice: feast his eyes or avert them. Every Christian man knows averting the eyes is most honoring to his wife and obedient to the Lord. So, he does. Still, he knows exactly at what point he and this woman will meet on the sidewalk. He hears her heels coming closer, and it takes all of his focus to keep his eyes elsewhere until she has passed. All day long he bounces his eyes away from temptations like this because he wants to honor his wife.

When he comes home, he can finally feast his eyes on the woman he spent all day honoring. However, she has the typical insecurities many women have and acts all embarrassed when he sees her getting dressed or showering. Her first reaction is to quickly cover up with clothes or a towel. She might also wear a bit more to bed in hopes the extra bulk will cover her imperfections. She dodges any contact or intimacy that might reveal an inch too much of her body.

Dear wife, your husband isn't being disrespectful and there is no need to be embarrassed. He only sees the beautiful creation you really are. It saddens him that he makes you so uncomfortable. Therefore, he does what is most respectable to you in

the moment; he averts his eyes in hopes of alleviating your apparent anxiety over his interest. Read the next sentence *slowly.*

He needs to see you strut your birthday suit.

He isn't focused on your cellulite, your flat chest, or your untoned thighs. He only sees the one he loves and wants to appreciate what the Lord designed for his eyes only. He feels great joy in being entrusted with you. And he would be most grateful if you would let him look at you.

A much-needed step most wives need to take is to increase their intimate engagement because men's emotions, confidence levels and sense of well-being are directly correlated with their bedroom life. Most wives don't understand that the way their husbands feel behind closed doors affects them so dramatically. Recognizing this truth, helps us wives realize that we can be a huge help to our husbands in the battle to stay pure. We can serve as an armor of sorts by blessing them with our bodies, letting him see and appreciate what they shouldn't get anywhere else.

So, drop the towel. Light a candle and allow him to see you in the soft glow. Wear a little nothing. Sleep naked. Send him a flirty text reminding him that you are waiting for him at home. He will appreciate any effort you make to help protect his heart against the readily available temptations today's culture offers.

Verses to Reflect Upon

*The Lord said "...get rid of the vile images you have set your eyes on,
and do not defile yourselves with the idols of Egypt. I am the Lord your God. But
they rebelled against me and would not listen to me,...So I said I would pour our
my wrath on them and spend my anger against them in Egypt."*

Ezekiel 20:7-8

Matthew 6:22-23

Ephesians 1:18-19

Prayer

Father, we know our eyes are the lamps of our bodies. With them we introduce either light or darkness into our hearts (Matthew 6:22-23). Give my husband the courage to guard his eyes from evil. Remove from him any desire to indulge his flesh in pornography, sexually explicit images, and crude humor. Convict him and move him to get rid of any evil-promoting practices so he will not defile himself.

Lord, I know You cannot tolerate wrong (Habakkuk 1:13). I believe that You will pour out Your wrath and spend Your anger on those who do not obey Your command to remove defiling images and idols (Ezekiel 20:7-8). Spare my husband from Your anger, and strengthen him to do as You bid in keeping his body, the temple of the Holy Spirit, pure. I pray You will be patient yet firm with my husband as You continue refining him in the area of guarding his eyes.

Jesus, I pray also that the eyes of my husband's heart will be enlightened so that he may know the hope to which You have called him. May he see the riches of Your inheritance and Your incomparably great power, and may this knowledge move him to further seek to guard and purify his eyes, the lamp of his body (Ephesians 1:18-19).

Father, I pray now that my lover, my husband, would find fulfillment by seeing and experiencing my physical body. I pray he would be enthralled by my form, seeing only beauty and flawlessness (Song of Solomon 4:7). May I "become in his eyes like one bringing contentment" (Song of Solomon 8:10), the one who delights his soul. In Jesus' mighty name, Amen.

Specific Prayer, Praises and Convictions

Fasting Challenge

Fast from sugary
foods and drinks.

Record them:

Other fasting choice:

Day 5

Guarding His Mind

Left to itself, the mind can single-handedly cause more pain and destruction than we like to admit. Just take a stroll through Romans 1:18-32, and we can see that although the people knew God they didn't position Him as God in their lives and, therefore, were given over to the very depravity they craved. They were filled with every kind of wickedness and became murdering, slandering, deceiving, gossiping, proud God-haters. Verse 31 says "they are senseless, faithless, heartless, ruthless."

Sounds exactly like the kind of man we all want for a husband (insert sarcasm). Yikes.

Another example of an obstinate, headstrong people can be found in Isaiah 65:1-12. They did exactly as they pleased. They pursued their own imaginations. They mocked God, and eventually, they were repaid what they desired. Verse twelve says that because they deliberately chose what displeased God, they were destined for the sword – death and destruction, full payment measured into their laps.

The same still applies today. When we choose to sin, we choose the consequences. All choices must first go through our minds, the place where we decide between good and evil. When we allow ourselves to pursue the imaginations and desires of an uncontrolled mind, we become enslaved to the diseases of it. We become overtaken by sexual immorality, fear, depression, exhaustion, filthy language, anger, and bitterness, to name a few. To top it off, we then start approving of those who do the same so we might be able to justify our sin (Romans 1:32).

Yet, God's Word says we are given power over this mind that is prone to run wild. We are given the authority and the ability to control our thoughts. We are urged to be transformed by the renewing of our minds. We do this by indoctrinating ourselves with what is true, right, pure, noble, anything Christ would find praiseworthy (Philippians 4:8).

What we find when we "take every thought captive and make it obedient to Christ" (2 Corinthians 10:5) is that we become more clear-minded and self-controlled. We become better able to test and approve what God's will is. We make better judgments in life's circumstances, and on a much grander scale, our better character starts attracting others to the love of Jesus.

Pray for your husband's mind to be cleared and renewed. Ask the Lord to empower him to stand against the attacks made on his mind. Bind up in prayer every evil plan the enemy may have to assault his mind with negative thoughts, impure thoughts, fleshly desires, anger, and the like. Pray that the Lord will bring to light anything that will hinder his focus or entice him to stray.

Verses to Reflect Upon

"Those who live according to the sinful nature have their minds set on what nature desires; but those who live in accordance with the spirit have their minds set on what the Spirit desires. The mind of sinful man is death, but the mind controlled by the Spirit is life and peace;"

Romans 8:5-6

"Do not conform any longer to the pattern of this world, but be transformed by the renewing of your mind. Then you will be able to test and approve what God's will is- His good, pleasing and perfect will."

Romans 12:2

Ephesians 4:22-24

2 Timothy 1:7

1 Peter 1:13

Prayer

Father God, You know and discern our thoughts and the intents of our hearts (Hebrews 4:12). Do not let my husband walk in ways that are not good, pursuing his own desires and imaginations. Instead, make him wise and discerning with a mind like Christ's (1 Corinthians 2:16), weighing his thoughts with the truth of Your Word.

Father, we know those who live according to sinful nature have their minds set on what that nature desires (Romans 8:5). We also know that because evil-minded people don't think it worthwhile to retain knowledge of You, You give them over to depraved minds. They become filled with all the wicked, senseless, faithless, heartless, ruthless things they desire (Romans 1:28-31).

Father, I stand in faith, praying You will not give my husband over to depraved thoughts which can result in all kinds of diseases of the mind. I pray You remove any spirits of fear, negativity, impurity, selfishness, anger, and the like from my husband's mind. Replace such things with a sound mind, one that has the power to think rightly and justly, one that dwells on Your truth.

I pray that my husband will not be conformed to any pattern of this world but be transformed by the renewing of his mind (Romans 12:2), taking captive every thought and making it obedient to You (2 Corinthians 10:5) so that he will be able to test and approve what is your good and perfect will in all circumstances (Romans 12:2).

Lord, I lift my husband to You to be made new in his thoughts. Convict him and enable him to stand against the enemy when an attack is made on his mind. Help him stand strong, clear-minded and self-controlled, so he can hear You when he prays (1 Peter 4:7). May he think only on things that are true, noble, right, pure, and lovely – whatever is admirable or praiseworthy – so that the peace of God which surpasses all understanding will be able to guard his heart and mind in Christ Jesus (Philippians 4:8,7). In Jesus' name, Amen.

Specific Prayer, Praises and Convictions

Fasting Challenge

Fast all meats.

Record them:

Other fasting choice:

Day 6

A Right Heart

You know that name you don't like? You know, the one you vehemently crossed off your husband's list of potential baby names? Most likely that name was ruined for you by someone who turned out to be ugly. Well, on the outside they probably looked okay, but once you got to know them, they turned all shades of dark and nasty. Maybe they hurt you, bullied you, took advantage of you, or slandered you. Whatever it was, there was just no way your child was going to bear the name of the one who wounded you.

Do you know what made that individual's name so ugly to you? His or her heart. It's a telling thing, really. If the heart is hard and ruthless, we spew evil and harshness. If the heart is gentle and genuine, we exude grace and love. Whatever the condition of our heart, so do we speak and live out our lives.

Romans 1 reads of the greatest sickness known to mankind: *although we know God, we do not honor Him as God.* As a result, our minds become futile and our hearts darkened to the point where we are overcome, filled with every kind of wickedness, evil, greed and depravity (Romans 1:18-32).

Read these truths about our hearts:

"The heart is deceitful above all things and beyond cure. Who can understand it?" (Jeremiah 17:8).

"...for their hearts plot violence, and their lips talk about making trouble" (Proverbs 24:2).

"The hearts of men, moreover, are full of evil and there is madness is in their hearts while they live, and afterward they join the dead" (Ecclesiastes 9:3).

"They are darkened in their understanding and separated from the life of God

because of the ignorance that is in them due to their hardness of heart" (Ephesians 4:18).

Yet, we needn't become discouraged. Yes, God gave us these human wants and wills, but instead of indulging, we can train ourselves to be purposeful in choosing the Lord's ways instead of our own. Being aware of our misleading hearts helps us be even more diligent in arming ourselves with truth. It's the "be alert and self-controlled" way of living mentioned in 1 Peter 5:8.

Here are a few practical ways to redirect and retrain our hearts:

- Pray for our hearts to be opened like Lydia's so we may understand the word of God (Acts 16:14).
- In humble repentance, choose to make His statutes our heritage and set our hearts on keeping His law to the end (Psalm 119:111-112). His law is to love from a pure heart, a good conscience, and sincere faith (1 Timothy 1:5).
- We store up God's Word in our hearts so that we may become established in His truth (Psalm 119:11).
- We think soberly on our lives, and ask God to teach us to number our days so that we may be given a heart of wisdom (Psalm 90:12).

Pray for yourself and your husband to be given spiritual heart transplants. Ask God to give you hearts that are pliable to His Word, have pure intent, are not self-seeking, and continue growing in sincere faith.

Verses to Reflect Upon

"Teach me Your way, O Lord, and I will walk in Your truth; give me an undivided heart that I may fear Your name. I will praise You, O Lord my God, with all my heart; I will glorify Your name forever."

Psalm 86:11-12

"The heart is deceitful above all things and beyond cure. Who can understand it? I the Lord search the heart and examine the mind, to reward a man according to his conduct, according to what his deeds deserve."

Jeremiah 17:9-10

Psalm 139:23-24

Read Hebrews 3:7-13. Write verses 12-13.

Hebrews 4:12

Prayer

Father, thank You for giving my husband a heart that is teachable. Even when he is unwilling to change his views or ways You, oh Lord, have the power to work in his heart making it pliable to Your will and Your ways. Create in my husband a new and a steadfast spirit (Psalm 51:10) for You have not given him a heart of stone but of flesh.

Your Word teaches us a good man brings good things out of the goodness of his heart, and the evil man evil things out of his heart (Luke 6:45). Let my husband stand firmly in righteousness that overflows from a heart ablaze for You. Teach him to walk in Your truth. Give him an undivided heart (Psalm 86:11), not one that entertains both good and evil.

Father, You have said, "I, the Lord, search the heart and examine the mind, to reward a man according to his conduct, according to what his deeds deserve" (Jeremiah 17:9-10). Search his heart, Jesus. Ever so gently, search his heart. Test him and know his thoughts. See if there is any offensive way in him. Convict him in any areas where he needs to grow more gentle, humble, kind, loving or repentant, then guide him into Your everlasting way (Psalm 139:23-24).

When the road gets hard, do not let his heart be troubled. Prove Yourself to my husband so his trust in You may be established, further purifying his heart by faith. May he praise You with all his heart, soul, and mind, glorifying Your name forever. In Jesus' name, Amen.

Specific Prayer, Praises and Convictions.

Fasting Challenge

Fast all solid foods. Choose broth, juices, and water.

Record them:

Other fasting choice:

Day 7

A Greater Faith

"According to your faith it will be done to you."

Matthew 9:29

That's a big statement. According to our faith, it will be done to us. While faith the size of a mustard seed has the power to move mountains, we are not invited to become content with such a small faith. Instead, we are encouraged to grow in our faith, becoming more like Christ, maturing as time goes on by the constant use of God's Word (Hebrews 5:12). At first we are fed the spiritual milk of God's Word because it is vital. But then we are encouraged to chow down on spiritual meat. A steak, if you will. We are told to grow up in the Lord, invited to get to know Him, asked to put our faith into action.

That can be scary. What if the Lord calls us to do that one thing we never wanted to do? If you had asked me when I was sixteen what I never wanted to do, some of that list would have included never leave the Amish, never walk through a teenage pregnancy, never move to Iowa, never lay on an operating table, never watch someone die, and never have to tell my son to keep his hands out of his pants.

A few short years later, I have done all those and a few more that I didn't know I didn't want to do.

However, the question is not how much do we have to go through, but rather what is our faith response? When we travel through the deserts of life, the times we aren't sure how we are going to drag our bodies off the floor, the times we wonder if we will ever smile again or even dare feel again – those are the times our faith either grows or dies. We get to choose. Are we going to place our hope and trust in the Lord, believing Him for His promises? Or are we going to cast our mustard-seed-sized faith aside and let it dehydrate?

Today, pray for the measure of faith your husband has been given. It is a gift to be cultivated and built upon, not buried in the ground like the man given the least talents in Matthew 25. Pray for your husband's faith to be strengthened. Pray for whatever hard things he currently faces. Pray that he would have courage enough to dip his toes in the waters of the unknown and stand there in faith. Ask the Lord to help your husband in any area of unbelief and to make His power evident in your husband's weaker moments. Pray for mountains moved, walls torn down, and seas parted, a greater faith.

Verses to Reflect Upon

"Yet he did not waver through unbelief regarding the promise of God, but was strengthened in his faith and gave glory to God, being fully persuaded that God had the power to do what He had promised."

Romans 4:20-21

"...that your faith might not rest on men's wisdom, but on God's power."

1 Corinthians 2:5

"And without faith it is impossible to please God, because anyone who comes to Him must believe that He exists and that He rewards those who earnestly seek Him."

Hebrews 11:6

James 1:6-7

1 Corinthians 16:13

2 Timothy 1:6-7

Prayer

Father, bless my husband with an extra dose of faith today. Reveal Yourself to him in mighty and undeniable ways. I pray You will be so apparent to him that his faith cannot rest on man's wisdom but only in Your great power (1 Corinthians 2:5). May He turn to You in all he does, knowing You reward those who earnestly seek You.

Father, remind him often what You have already done for him so he doesn't forget Your faithfulness. May his faith grow to new heights as he becomes fully persuaded that You have the power to do exactly what You have said You will (Romans 4:21).

When he asks anything in Your name, help him not doubt You (James 1:6-7). Where there may be a tinge of doubt, help his unbelief. Strengthen His trust in Your power, Your ways, Your ability, and Your promises. Where he is weak, display Your strength. When his faith is timid, feed him courage and boldness. Where his faith has grown complacent, renew it like a wildfire, burning and blazing – yearning for more of You. Do not let any unbelief or doubt outweigh his hope and trust in You so that at the end of his long faith-filled life, he may stand before You and confidently say, "I have fought the good fight, I have finished the race, I have kept the faith" (2 Timothy 4:7). In Jesus' Name, Amen.

Specific Prayer, Praises and Convictions

Fasting Challenge

Fast one meal.

Record the meal:

Other fasting choice:

Day 8

A Better Attitude

Being around people with negative, sour, or self-centered attitudes is much like letting a balloon slip from your fingers before you tie it. It deflates our spirits, exhausts our joy, and if we don't remove ourselves from the situation, it can spiral our day into all kinds of crazy fashions, eventually dropping us into a sad-looking heap.

It sounds a bit like something the contentious woman mentioned in Proverbs would be capable of accomplishing. Surely somewhere in her bag of attitudes she could pick a better one.

God's Word tells us that we are to put off the tendency to think like the world and be made new in the attitudes of our mind so we may gain a mind like Christ's. We do this by thinking on the things He would find pleasing. We are called to an attitude of servant-hood – one that doesn't allow us to think more highly of ourselves than we ought (Romans 12:3). One that seeks the better gain of others. One that does nothing out of selfish ambition or vain conceit. One that considers others better than ourselves (Philippians 2:3).

Such an attitude is simply not doable in our own strength. Far too often human nature kicks into overdrive and leaves humility locked in the starting gate. While Jesus displayed the perfect example of humility and love, our human nature says we like what we like when we like it, and should anyone dare hinder our desires we balk, snort, wheeze, whine, and gripe at a moment's notice.

Only through much prayer and practice can we become more humble with time. When we ask the Lord to indwell us and purposely set our minds on seeking His wisdom and ways, His characteristics will start becoming evident in our lives. The fruits of a renewed mind will be attitudes of love, joy, peace, patience, kindness,

goodness, faithfulness, gentleness, and self-control. Yes, the fruits of the Spirit. They are the opposite of a life left to the reins of human nature.

Pray for your husband to seek an attitude of humility, to rid himself of the tendencies toward anger, frustration, and all others that do not edify Christ. The word *rid* means to purge or clean out. Pray for your husband to be cleansed of all inclinations toward harshness, rudeness, indifference or pride. In those places, ask for the fruits of the Spirit to take root, completely making over his character and disposition.

Verses to Reflect Upon

*"Rid yourselves of all offenses you have committed
and get a new heart and a new spirit."*

Ezekiel 18:31

*"Do not think of yourself more highly than you ought,
but rather think of yourself with sober judgment, in accordance
with the measure of faith God has given you."*

Romans 12:3

Ezekiel 36:26-27

Read Philippians 2:3-8. Write what speaks to you most.

Titus 3:1-2

Prayer

Dear heavenly Father, thank You for giving my husband a sound mind (2 Timothy 1:7). I pray You would guard his heart and mind so his thoughts may be found pleasing in Your sight.

Father, enable my husband to steer his attitude correctly. Remind him often to humble himself before You as Jesus did, taking on the nature of a servant, willing to serve those around him in love (Philippians 2:5-8). Give him a desire to obey Your Word. Help him to be ready to do whatever is good, to avoid slander, to be peaceable and considerate in all that he does, showing true humility toward all people (Titus 3:1-2).

Jesus, it is in Your name that I take a stand against any attitudes of pride or self-righteousness that might be taking root in my husband even now. Pluck out the old mind sets and in their stead, plant new and holy ones, Father. Give him wisdom and grace to honor others before himself, always devoted to those around him in brotherly love (Romans 12:10).

Father, put a right spirit in my husband, one that is ready to follow Your will and Your ways all the days of his life. In Jesus' name, Amen.

Specific Prayer, Praises and Convictions

Fasting Challenge

Fast all beverages excluding water.

Record the beverages:

Other fasting choice:

Day 9

His Love for Others

"And this is love: that we walk in obedience to His commands.
As you have heard from the beginning, His command is
that you walk in love."

2 John 6

As I read this passage again, I was struck by the correlation between love and obedience. When we love the Lord, we obey His commands. When we obey His commands, we are simply putting action to our love for Him.

As I pondered these thoughts, I was reminded of the famous love chapter, 1 Corinthians 13. In it, we find fourteen principles of what it looks like to walk in love that is truly love, the very characteristic of God. These apply to every relationship we have in life – marriage, parenting, in-laws, neighbors, whoever crosses our path.

1. Love is patient.

Being patient and understanding toward others takes a lot of wisdom and practice. Laying down our desires or giving of our time is not popular in this self advancing culture. However, Ephesians 4:2 gives the reminder "Be completely humble and gentle; be patient, bearing with one another in love." The words *"bearing with"* mean to hold on, wait, or tarry alongside of others, help them along graciously, nurture them, encourage them; be patient in your dealings with them.

2. Love is kind.

Pure love is compassionate toward others, sensitive to their needs, merciful and generous. It is a good love, always kinder than necessary in all things.

3. Love does not envy.

Envy is an evil thing. It spreads like wild fire through gossip, feeds on unforgiveness, and fertilizes the growth of bitterness and contention. If not dealt with properly, envy will eat away at our spiritual bones, robbing us of joy and contentment.

Proverbs 14:30 says, "A heart at peace gives life to the body, but envy rots the bones." Through forgiveness and reconciliation, love promotes life and peace long before envy can start it's decay.

4. Love does not boast.

Self-promotion, pretentious attitudes, bragging and gloating are all the equivalent of boasting. Love can't stay where those are, so don't participate in such things.

5. Love is not proud.

Pride goes hand in hand with boasting. Think of the last time you stood beside a pride oozing individual. Maybe you felt belittled, irritated, and even a bit suffocated by their haughty attitude. Proverbs 11:2 warns, "When pride comes, then comes disgrace". Avoid bringing shame and dishonor into your life by eliminating pride.

6. Love is not rude.

Rudeness is never acceptable behavior. Love builds relationships by overriding the urge to be abrupt, sharp or ill-mannered in any way.

7. Love is not self-seeking.

Self-seeking people are those who manipulate, connive, and approve of anything that promotes themselves. Love, however, is sincere – genuinely concerned about another's greater good. They "look not only to your own interests, but also to the interests of others" (Philippians 2:4).

8. Love is not easily angered.

Anger is a powerful emotion. However, a short temper or uncontrolled outbursts of anger will make people fear you. Inducing fear in others is not the rudder that guides healthy relationships. Anger is manipulative. Love sets heart a-sail.

9. Love keeps no record of wrongs.

Holding grudges will sap the joy and peace right out of us. Love forgives early and first. Love doesn't expect perfection. It allows others their flaws, covering it all in grace.

10. Love does not delight in evil, but rejoices with the truth.

Being dishonest or deceptive in any way will drive a wedge of distrust deep into the hearts of those around you. Be truthful and transparent – "an honest witness does not deceive" (Proverbs 14:5).

11. Love always protects.

Love protects others by being a safe, warm place for them. A place where they are welcomed, cared for and nourished. The Lord Himself leads us to places where our soul may find rest. Be the person who refreshes others (Proverbs 11:25), the one who protects and cherishes the hearts around her.

12. Love always trusts.

The opposite of a trusting person is one who is critical, suspicious or skeptical of others. Even after a broken trust, love – the love that obeys the Lord's commands – reserves the power to forgive and keep no record of wrongs.

13. Love always hopes.

Even in difficult relationships, love still anticipates healing and change. Love expects there to be purpose in the trial, helping us respond in the ways that model the way God loves us.

14. Love always perseveres.

Walking in love is not always easy, but it is always appropriate. The Lord loves us with a steadfast love and as His children not only does He ask us to imitate Him, but He also empowers us to do so. So, don't give up. Remain devoted to His command to walk in love. Persevere in a love that is true, sincere, and powerful. For when we do, we have the promise that "love never fails" (1 Corinthians 13:8).

Today, pray for yourself and your husband to be so filled with Christ's love that it spills over into all other areas of your lives, completely transforming your marriage and your home. Pray that the desires of your hearts would shift into ones that put the power of Christ's love on display for all to see.

Verses to Reflect Upon

"Love must be sincere. Hate what is evil; cling to what is good.
Be devoted to one another in brotherly love."

Romans 12:9-10

"Nobody should seek his own good, but the good of others."

1 Corinthians 10:24

John 15:13

Ephesians 5:1-2

1 Corinthians 13:1-3

Prayer

Father, I praise You for sending Your Son and giving us the perfect example of love: to love others the way they *need* to be loved and not how they deserve to be loved. I pray You will put such a love in my husband's heart, a love that's unselfish and doesn't expect compensation.

Father, I pray my husband will do nothing out of selfish ambition or vain conceit but will, in humility, consider others better than himself. Teach him not to seek his own ways, or have ulterior motives when he serves others, but to be genuinely concerned about their well-being. Teach him that love is patient and kind, not envious, boastful, proud, rude or easily angered (1 Corinthians 13:4-8). Help him lay down his will and plans when it is edifying to others to do so. May he see that in humbling himself, he is not giving up or being shamed, but rather through his deference to other people, he will receive a more lasting reward in the future.

Father, soften my husband's heart toward me and our children. Teach him to give himself up for us. Give him wisdom and understanding when dealing with his children. Help him persevere in living out a patient, forgiving love. May his kindness be a beautiful model of the way You love us, making You appealing and approachable to our children. Father, also help my husband display a pure love toward me. As leader of our marriage, help him be selfless and give more than he takes. Enable him to live out of the powerful love that always trusts and always protects.

Father, I pray my husband will learn to love You more and more each day. Remind him often that neither life nor death, neither angels nor demons, neither the present nor the future, neither height not depth, nor anything else in all creation, will be able to separate him from Your great love (Romans 8:38-39). May knowing this give him an ever increasing desire to walk in obedience to Your command to love. In Jesus' precious name, Amen.

Specific Prayer, Praises and Convictions

Fasting Challenge

Fast from all electronics.

Record them:

Other fasting choice:

Day 10

Finding Joy in Trials

L ife is full of joy robbers. From the times when life seems a bit bland to trials that immobilize, the enemy is always meddling in the middle trying to deceive us into believing that life is meaningless and without purpose. The Bible, however, reminds us that even our most grievous times will be turned to joy (John 16:20).

Yet, how is it possible, we ask, that trials could lay the ground work for a greater joy to come? Where is this refreshing hope? How can we find the strength to breathe when all is not well with our soul?

The Psalms are a great verbal image of how the highs and lows of life affect us. They teach us Who King David set his trust upon causing him to say, *"Therefore my heart is glad and my tongue rejoices"* (Psalm 16:9).

Looking deeper into this verse and the eight verses before it, we find King David found joy in his trials because,

- He knew that apart from God he could have no good thing (Psalm 16:2)
- He recognized that the Lord had assigned him his portion and cup, whether it was full of pain or pleasure. Either way he trusted his lot was secure in the Lord (Psalm 16:5).
- He chose to be thankful for what the Lord had given him. He chose to praise the Lord for how his life was panning out by saying, "The boundary lines have fallen for me in pleasant places; surely I have a delightful inheritance" (Psalm 16:6).
- He decided to praise the Lord (Psalm 16:7). David's life wasn't all roses. He had some really smelly things dealt to him. Still, he sought the Lord's face.

- He placed his hope solidly in the Lord. David said, "I have set the Lord always before me" (Psalm 16:8), meaning he resolved to trust the Lord even in the hardest times of life.

Therefore, verse nine says, his heart was glad and he was able to rejoice.

The enemy knows that lack of joy promotes insignificance of hope. So he will attempt to convince us that our lives, our marriages, and our faith are all pointless. So often we think of joy as being excitement, something that makes us feel happy. Friend, happiness is fleeting and topical; it comes and goes depending on our activities and the people we are around. Joy, however, is a soul emotion; a deep connection flowing between Creator and creation.

Joy comes through our faith and knowledge of the Lord. The more we seek Him the more He reveals Himself, filling us with the joy and confidence of His presence. Today, implore the Lord to infuse you and your husband with His presence. Ask the Father to teach you satisfaction and peace in all the difficult seasons of life. Resolve to set the Lord always before you so you might default on trust when trials blaze.

*"When anxiety was great within me,
Your consolation brought joy to my soul."*

Psalm 94:19

"For the joy of the Lord is my strength."

Nehemiah 8:10

*"...I will rejoice in the Lord, I will be joyful in God my Savior. The Sovereign
Lord is my strength;... He enables me to go the heights."*

Habakkuk 3:18-19

Psalm 13:5-6

Psalm 16:11

Psalm 30:11

Prayer

Dear Heavenly Father, thank You for promising Your strength to us. We find joy in being able to rely on You when trials blaze. I pray that Your consolation during the harder times of life will be a source of joy for me and my husband. Do not let us be distraught and burdened beyond what we can bear. Let us rest in knowing You bring nothing that will harm or destroy Your faithful ones.

Father, I pray specifically for my husband, that You would teach him to see trials for what they are: the testing of his faith. Help him endure Your refining work as an examination of his belief in You. Through the trials prove to my husband that You are his strength, his source of joy, and that You enable him to go the heights (Habakkuk 3:18-19) Father, when he has remained steadfast in You, complete his joy as he looks back and sees growth and maturity in himself (James1:2-4).

Help my husband ever trust in You, Father, no matter what storm or season he faces. When life is easy for a time, help my husband see it as a gift from You. Help him not take it for granted but to continue to prepare his heart and mind with Your word. When he is crossing turbulent waters, teach him Your unfailing love so he will not be shaken. Grant him eternal blessings and make him glad with the joy of Your presence (Psalm 21:6-7). In Jesus' name, Amen.

Specific Prayer, Praises and Convictions

Fasting Challenge

Fast from sugary
foods and drinks.

Record them:

Other fasting choice:

Day 11

Claiming Peace

There was a time when fear and anxiety gripped Mike's heart and nearly immobilized him. He spent many nights in a panic, at times sitting bolt upright in bed and gasping for breath. Life was cold and harsh for him. Suicidal thoughts crept in, and he felt alone, completely powerless against his fears.

Mike's wife, Alyssa, watched as his eyes slowly turned into deep pools of despair and nothingness. She longed for him to be set free from the unsettling in his soul. She took to heart the promise and instruction found in Philippians 4:6-7, "Do not be anxious about anything, but in everything, by prayer and petition, with thanksgiving, present your requests to God. And the peace of God, which transcends all understanding, will guard your hearts and your minds in Christ Jesus."

Alyssa started praying specific prayers over her husband, calling out and renouncing fear, anxiety, unrest, turmoil and anything that did not promote peace. She brought her every request and desire for Mike's healing before the Lord, and pleaded the blood of Jesus over his mind and soul. Today, Mike has found complete freedom from the monsters that once paralyzed him. Peace now reigns in his heart and mind, guarding them just as the Lord promises.

This "peace that passes all understanding" is something all humankind may lay claim to in Christ. It provides the hope we long for, the patience we need, the wisdom we ask for, and the nurturing our souls so desperately desire. Yet, we cannot grasp this peace in and of ourselves. We must seek the Peace-Bringer Himself before we may partake of it. There is no substitute for it and there is no end to it. It draws us in, this blessed repose, and makes our hearts crave it all the more.

Each time His peace is proven adequate for our needs, we are reminded that our most difficult situations do not compromise the sovereignty of God. The more we

depend upon Him the more we find satisfaction in Him. So we must not allow the cares of this world obliterate our blessed assurance within.

Today, petition the Lord's heart for His peace. Repeatedly and relentlessly return to Him for another dose of His heart. Recklessly crave Him. Ask the Lord to anoint both you and your husband with a quiet confidence that can claim, "It is well with my soul, when all is not well with my circumstances."

*"Great peace have they who love Your law,
and nothing can make them stumble."*

Psalm 119:165

*"You will keep in perfect peace him whose mind is steadfast,
because he trusts in You."*

Isaiah 26:3

*"Do not be anxious about anything, but in everything, by prayer and petition, with
thanksgiving, present your requests to God. And the peace of God, which transcends
all understanding, will guard your hearts and your minds in Christ Jesus."*

Philippians 4:6-7

Numbers 6:24-26

Psalm 33:20-22

Prayer

Dear Heavenly Father, in this world we are promised trouble, yet in You, we are promised peace. We take heart in the knowledge that You have overcome the world (John 16:33), and that in You we may have peace at all times and in every way (2 Thessalonians 3:16).

Father, when darts of the evil one are being fired from all directions, keep my husband's mind steadfast on You desiring Your peace and Your presence. Help him to not be anxious about anything, but in everything, make his requests known to You by prayer and petition (Philippians 4:6-7). Impart peace beyond measure upon him, reassuring him that You are not slack in Your promises. May Your blessed assurance keep him from succumbing to temptations of despair, hopelessness, depression, or distrust in You.

Father, move my husband's heart to also promote peace in all he does by not being quick to argue or seek revenge. It is to a man's honor to avoid strife, but every fool is quick to quarrel (Proverbs 20:3). Lord, You have not made my husband to be a fool, but a man of courageous faith. Help him be kind, patient, and loving, making every effort to do what leads to peace and mutual edification of those around him (Romans 14:19).

May my husband's heart overflow with Your peace, Father, and spill out of his life for all to see. I ask that You now give him a desire to love You and want to serve You more and more each day. In Jesus' name, Amen.

Specific Prayer, Praises and Convictions

Fasting Challenge

Fast all meats.

Record them:

Other fasting choice:

Day 12

Growing in Patience

Ah, yes. Patience is a virtue, they say. Enduring without complaining, remaining calm, being tolerant and long suffering, staying diligent, persevering, pressing on in the dark... it all sounds rather uncomfortable. A tad painful even.

It isn't glorious to be in the trenches of life, but invariably that is where patient faith grows from. James 1:2-4 reminds us:

> *"Consider it pure joy, my brothers,*
> *whenever you face trials of many kinds,*
> *because you know that*
> *the testing of your faith develops*
> *perseverance.*
>
> *Perseverance*
> *must finish it's work so that you*
> *may be mature and complete,*
> *not lacking anything."*

What we see in this passage is confirmed in John 16:33, which says we are promised trials in this world, yet when they come, we must remember that Jesus already overcame the world. So it is with joy that we bear the testing of our faith because testing brings about the perseverance that matures our faith.

Perseverance is an interesting word. In short, it means to persist, to remain steadfast, to hold out to the end; to have some grit to our faith. The willingness to stand firm on God's Word when the seas of life crash upon us is evidence of perseverance. As we remain faithful to Him, trusting Him to see us through it all, we emerge from the storm stronger than before. We might feel a bit battle-worn, but we become more mature and complete as we arrive at a faith that has more grit.

With an eternal perspective in the darker times of life, we can look deep into the tunnels and know that while we may not understand it all, we can trust Him to know what He is doing. It is in that confidence that we find reason to be grateful in the trials. We can celebrate His sovereignty knowing He is going to bring good things from all our struggles.

In this next little poem, *Growing Grateful*, we are reminded of the purpose for trials; to establish us ever more faithful and dependent on our Rock. And through it all, when we know Who carries us, we are enabled to endure the trials patiently.

Continue in His ways, persevering through the waves that threaten to overtake you. He promises in Isaiah 43:2, "When you pass through the waters, I will be with you". And that is exactly what waters do – they pass. So do trials. Endure them with patience. Do not be surprised when you face struggle. Place your whole hope on the Lord; His strength will not fail you.

Today, ask the Lord to grow you and your husband more patient, persevering in whatever the days may hold. Ask Him to shape and mold you into greater wisdom and wholeness, developing an enduring faith that has the grit to go the long haul.

Growing Grateful

the house imperfect,
the marriage lows,
the parenting struggles,
relationships ended,
the pain of rejection,
the hurt of words,
the struggle with addiction,
the struggle to submit,
the struggle with "self",
the suddenness of death,
the gut wrench of suffering,
the disease uncured,
the hurt before healing,
the loss of innocence,
the trusts betrayed,
the lonely nights,
the barren days,
the rocky past,
the future uncertain….
In it all, God remains.
growing me up,
growing me wise,
growing me strong,
growing me faithful,
growing me trustworthy,
growing me gentle,
growing me kind,
growing me joyful,
growing me patient,
growing me grateful.

—Kaylene Yoder

Day 12 Growing in Patience

Verses to Reflect Upon

"A hot tempered man stirs up dissension, but a patient man calms a quarrel."

Proverbs 15:18

"A man's wisdom gives him patience; it is to his glory to overlook an offense."

Proverbs 19:11

*"Be completely humble and gentle; be patient,
bearing with one another in love."*

Ephesians 4:2

Colossians 3:12-14

1 Thessalonians 5:14

Prayer

Father, thank You for being a patient God. Thank You that Your mercies are never ending. I pray You will give my husband a heart that is patient and understanding, one that will go the distance of bearing with others.

Your word tells us a man's wisdom gives him great patience and that it is to his glory to overlook an offense (Proverbs 19:11). Anoint him wisdom and help him choose patience in all circumstances.

Father, convict my husband to let go of any impatience, grudges, anger, jealous tendencies or harsh words. In their place, teach him to be completely humble and gentle, bearing with others in love (Ephesians 4:2). When people are difficult or plans don't turn out as expected, give him an accepting attitude. Help him see that Your way is never wrong and that the testing of his faith will invariably include the testing of his patience. Help him clothe himself with kindness and compassion (Colossians 3:12-13),and persevere in doing what is good.

Fill my husband with the knowledge of Your will through all spiritual wisdom and understanding. I stand praying that by Your power he will live a life worthy of You. May he please You in every way: bearing fruit in every good work, growing in the knowledge of God, and being strengthened according to Your glorious might so that he may have great endurance to run the race marked out before him (Colossians 1:9-11). In Jesus' precious name, Amen.

Specific Prayer, Praises and Convictions

Fasting Challenge

Fast all solid foods. Choose
broth, juices, and water.

Record them:

Other fasting choice:

Day 13

Practicing Kindness

Tim was well known in his town. He was the man in the mansion whom everyone made way for on the street. He was a hard worker. But he was also a hard man. His body language showed tension and gruffness that could be seen from a block away. Head down, he walked with firm, demanding steps that caught everyone's attention and caused them to move aside so he could pass. He repelled people and hurt them.

He was the epiphany of an unkind, ungentle, human cactus.

In all honesty, there are days I could be Tim. You know, those days when the hormones rage, the kids are constantly in each others' grill, the sun hasn't shown in ninety-six hours and there is no chocolate in the house. Not even one measly off-brand chocolate chip.

Yes. *Those* are the days I tend to be a bit prickly in nature. While most of us want to be a blessing to our husbands and families, it's in those high intensity moments that we stray from gracious mannerisms.

It takes a conscious effort to bless someone with kindness. Otherwise, time slips by, love tanks begin to feel drained and everything spirals downhill from there. In my mission to be a blessing to my husband, I've found a few simple ways to cultivate a kinder heart and attitude toward him. These next three points are nothing revolutionary in themselves, however, putting them into action is the key to gifting others with kindness.

Pray continually.

My guess is, as you have been praying over your husband these past days your heart has softened a bit toward him. Possibly your demeanor has changed, as well. As we draw closer to the Lord, He fills us with more of Himself, completely renewing our

minds and attitudes. Consistent, specific prayer starts working in the heart of the one praying before it benefits the one being prayed for. Prayer empowers us to show a Jesus kind of love to those around us.

Listen and notice.

Personally, I don't like feeling as though I need to compete with a phone, a book, a TV, or anything else for my spouse's attention. So, when your husband walks into the room, notice. Acknowledge his presence with a smile and eye contact. Try pausing whatever you're doing and giving him your full focus for a few brief seconds by turning your body toward him. Look at him. Listen intently. Notice your husband's presence; it is a painless way to show him kindness.

Speak kind words.

Proverbs 31:26 tells us that a woman of noble character, "speaks with wisdom, and faithful instruction is on her tongue." Is what comes out of our mouths beneficial to those hearing it? Sadly, that's not always the case, so it is important to taste our words before we blurt them out.

An easy way to allow your husband to hear you speak kind words is to thank him for something he did for you. Did he take out the trash? Thank him. Does he bring home a paycheck? Thank him. Did he mow the lawn? Wash the car? Pick up a jug of milk? Thank the man. Verbalize your appreciation for him.

It really doesn't take much to bless someone with kindness. Pray to this end for yourself and your husband: that you and he would make it your goal to out-do one another with kindness.

Verses to Reflect Upon

"A kind man benefits himself, but a cruel man brings trouble on himself."

Proverbs 11:17

"Renounce your sins by doing what is right, and your wickedness by being kind to the oppressed. It may be that then your prosperity will continue."

Daniel 4:27

"Consider therefore the kindness and sternness of God: sternness to those who fell, but kindness to you, provided that you continue in His kindness. Otherwise, you will be cut off."

Romans 11:22

Proverbs 14:31

1 Thessalonians 5:15

2 Peter 1:5-8

Prayer

ather, thank You for Your kindness. Your mercies are never ending, reaching even to the ungrateful and wicked. Teach my husband to be kind to others, to love his enemies and do good to them (Luke 6:35). May he never pay back wrong for wrong, but always be kind to all people (1 Thessalonians 5:15).

Father, I pray You would move my husband's heart to rid himself of any bitterness, rage, anger, brawling, slander or any other form of malice. In their stead grow him to be kind and compassionate toward others, forgiving others as You have forgiven him (Ephesians 4:31-32). May he not have ulterior motives for being kind, but may true compassion permeate his words and actions.

I pray that You would prosper my husband and greatly reward his upright and pure life, Father. Your word says a kind man benefits himself (Proverbs 11:17). May my husband benefit long term peace of mind and good reputation. May he be a workman approved by God, not being made ashamed of ways he deals with others. In Jesus' name, Amen.

Specific Prayer, Praises and Convictions

Fasting Challenge

Fast one meal.

Record the meal:

Other fasting choice:

Day 14

Becoming Good

When God created the earth, it was beautiful. It was fresh, new, pure, and undefiled. Every thing and every activity in it was good; made from Him, through Him and to Him (Romans 11:36). Then the world lived for a while and things went south. The goodness He had created ate a bad fruit and ever since humankind has been infected by sin.

However, deep inside each person remains the ability to recognize anything that is good and right. An act of kindness, a beautiful spring day, a person of honest character – all of those are deemed good. We see the "be the good" slogan all around us, encouraging even the ungodly to pursue upstanding character. Wives are instructed to bring good to the heart of her husband (Proverbs 31:12) and from Colossians 3:19 we gather that husband's are to be good to their wives.

In pursuit of becoming good we must realize that we can be good and not be godly. However, we cannot claim godliness without also doing good. So, in becoming the good that is truly good, we take to the Word of the One who created good and He says, "All Scripture is God-breathed and is useful for teaching, rebuking, correcting and training in righteousness, so that the man of God may *be thoroughly equipped for every good work*" (2 Timothy 3:16-17 *emphasis mine*).

We gather many instructions from God's Word, such as the following two points, which will bring about a life that is truly good after salvation.

Becoming truly good means we must train ourselves to be godly.

"[T]rain yourself to be godly. For physical training is of some value, but godliness has value for all things, holding promise for both the present life and the life to come" (1 Timothy 4:7-8). There are many effective tools to help train us in godliness, but the best are ones we already have – the Bible and our minds. There is no substitute for

God's Word. It speaks like no other book on the planet. The more we marinate in it the more we become like the author. The more we know what the Word of God says, the more we sharpen our minds, training ourselves to recognize wrong teachings early on. Write Hebrews 5:14.

Becoming truly good means we must be disciplined.

Peter speaks often of being (a) clear minded and (b) self-controlled. In First Peter alone he mentions it three times (1 Peter 1:13, 4:7, 5:8).

> **(a)** Being clear-minded means we don't leave our minds unattended. We leave no room for the enemy to weasel his evil into our hearts and minds. Being disciplined enough to guard our thoughts by focusing on truth,will help us be transformed in our minds, able to judge what is good and right in the Lord's eyes. Write Ephesians 4:22-24.

> **(b)** Being self-controlled means we are commander of our emotions and how we express them. Ephesians 4 goes on to mention a few actions that would require self-control. For example, watching what we say, not indulging in fits of anger, but rather showing compassion toward all people. Write Ephesians 5:15-16.

Being and doing good in the eyes of the Lord should be our lifelong mission. Keeping our lives in right standing and training ourselves in the knowledge of the Lord, will give us the confidence to walk boldly forth and do as He bids. Pray that the

Father's wisdom and character will permeate you and your husband giving you the ability to lead the good lives He desires.

Verses to Reflect Upon

"A good name is more desirable than great riches;
to be esteemed is better than silver or gold."

Proverbs 22:1

"Test everything. Hold on to the good. Avoid every kind of evil."

1 Thessalonians 5:21-22

"Live such good lives among the pagans that, they may see your good deeds and
glorify God on the day he visits us."

1 Peter 2:12

Jeremiah 6:16

Romans 12:9

Galatians 6:9-10

Prayer

Dear Jesus, thank You for the good You have shown my husband throughout his life. Thank you for the times You kept him from making bad choices; the times You intervened to save His life, soul, and reputation. Let him see that the favor that has come to him is not of his own doing, but from You.

Father, I pray my husband will not seek his own good or be selfish in his motives, but that he would seek the greater good of those around him (1 Corinthians 10:24). May he work toward mutual edification in all situations, so that even pagans can see Your work of goodness through him (1 Peter 2:12). Father, I pray You would impress upon him to lead a disciplined life and be clear minded and self-controlled. May he not grow weary in doing what is right, for at the proper time You promise a harvest if he doesn't give up (Galatians 6:9-10).

Father, teach my husband to seek You first and by the constant use of your Word, train himself in godliness. When he is at the crossroads of good and evil, pour out Your wisdom and discernment upon him so he may know the way that is good. Then, may Your peace surround him encouraging him as he goes the way of uprightness. In Jesus' name, Amen.

Specific Prayer, Praises and Convictions

Fasting Challenge

Fast all beverages excluding water.

Record the beverages:

Other fasting choice:

Day 15

His Faithfulness

I find word history and origins very interesting. They often provide a telling and vivid spin to the word so that we never use it quite the same again. I find that to be true with the word *gird*.

It's a word found more often in the Old Testament and usually found in the context of someone going into battle. The men would be told to *gird up* their loins (Jeremiah 1:17 KJV), which meant to tie up their long flowing robes in a fashion that would allow their legs to be free and bare. Basically, they were to turn the bottom half of their robes into a pair of boxers. A big poofy diaper looking thing. Don't laugh.

In other places we read of men *girding* their swords to their sides (Psalm 45:3). This was also done when getting ready to go into battle. The process of girding swords to their sides involved tightly strapping swords to their belts and thighs.

These physical preparations meant the army was ready for war and whoever they were about the attack should be concerned for their own livelihood. Just imagine whole fields of men in long robes suddenly girding up their loins, and strapping down their gear, transforming from a demure looking flock into a locker room type mob complete with "rah-rah," "get your manly on" pep talks.

I'd be scared, too.

Girding up showed power, strength and readiness. Now apply this knowledge of "girding" to the spiritual battle we find in Ephesians 6:10-18. Verse fourteen in the KJV uses a form of our word, saying, "Stand therefore, having your loins *girt about* with truth..." (*emphasis mine*). Essentially it's saying put on your girdle of truth – wrap up tightly around you what is the knowledge of God. Put on this garment of truth first, wearing it closest to you so that it will help you distinguish good from evil.

Then we may continue preparing ourselves for this spiritual battle we are in. The

remainder of the armor God would have us wear is some pretty heavy gear. Take a look:

The breastplate of righteousness – This means to be in right standing with the Lord by how we apply His standards to our lives. Faith accompanied by action equals righteousness.

The shoes of peace – Putting on the shoes of peace means no matter what we walk into, we do not need to be frightened by the situation. We may be facing the biggest storm of our lives right now, but the storm does not need to live in us because Jesus does. There is no place for any other.

The shield of faith – The shield refers to being completely grounded in Christ and living out our faith in whatever we are called to. This shield, when held firmly in place, deflects the arrows of the evil one. So hold on to it with all you've got. Should your shield start feeling a little battle worn and weary, ask the Lord for more. He will supply you more faith.

The helmet of salvation – This is the hardhat that tells the enemy exactly who you are: a child of God. It reminds him that if he dares play games with you, he should expect defeat because your umpire, coach and teammate is Jesus, the One who already has, and forever will, triumph over him. Don't you dare take off this hat or try to leave God's team. Let the enemy know who you are and Whose you are. Strap it on and claim your status.

The sword of the Spirit which is the word of God – The Bible. It's alive. It's fresh. It's proven. It's God's and He speaks to us through it. Read it; memorize it; believe it; live it.

God's armor is designed to help us stand strong and be faithful to the Lord and His ways. He doesn't leave us defenseless to the enemy's whims. He's given us a whole wardrobe and then He follows up with an attack plan in Ephesians 6:18:

"And pray in the Spirit on all occasions with all kinds of prayers and requests... be alert and *Always. Keep. Praying.*" (*emphasis mine*)

So that's what we are going to do. We are going to implement the Lord's battle plan and pray that you and I and our husbands would remain faithful to the Lord. Let's pray that we would wrap ourselves up in the girdle of His truth, bear up under the breastplate of right standing, strap down the sword of His Word, tie up those shoes of peace, tighten our hardhat of salvation, and hold out that shield of faith.

Then, let's not forget to pray and bring our greatest Warrior, Jesus, to our greatest battle – the battle the enemy wages against our faithfulness to the Lover of our Souls.

By all means, girlfriend, *gird up*.

"The Lord preserves the faithful,..."

Psalm 31:23

*"Now it is required that those who have been given
a trust must prove faithful."*

1 Corinthians 4:2

*"Be on your guard; stand firm in the faith; be men of courage;
be strong. Do every thing in love."*

1 Corinthians 16:13-14

Psalm 45:3

Isaiah 11:5

Jeremiah 1:17

Prayer

Jesus, thank You for Your faithfulness, even to the cross. You have proven to be our Rock. All Your ways are perfect and just. You, O Lord, are a compassionate and gracious God, slow to anger, abounding in love and faithfulness (Psalm 86:15).

I pray You would give my husband an abundant desire to grow in Your likeness. Teach him to be a man of courageous faith, standing for what is good and right in Your eyes. I pray he will be on his guard against anything that does not bring life and godliness. Make righteousness to be his belt and faithfulness the sash around his waist (Isaiah 11:5). Help him bear up under the armor You provide by girding himself in truth, so he may be able too discern good from evil. Help him be wise to the ways of the world and the lord of it, the enemy.

Father, give my husband the courage to apply Your standard to his life so that he may be known as a righteous man. When the road is dark before him help him put on the shoes of peace so that he may not be frightened. May he stand strong in his faith, claiming his status in You.

Father, now I lay open our marriage before You. Help us stand strong using the Sword of the Spirit, Your Word, as our guide and protection against temptation. May we not yield to anything that could blemish our lives or compromise our marriage covenant. Help us renounce anything that does not bring honor and glory to You. Grow our love for You to be greater than our love for each other, for in that way we may be strengthened to remain faithful to each other.

Lord, I specifically lift my husband to You now. Make him a man pure in thought and deed, always being guided by Your word so that he may live his life holy and blameless before You. May Your Word be written on the tablet of his heart so that his faithfulness to You may become more and more evident each day. In Jesus' name, Amen.

Specific Prayer, Praises and Convictions

Fasting Challenge

Fast from all electronics.

Record them:

Other fasting choice:

Day 16

Practicing Self-control

If you've been married any length of time, your husband has probably wanted something that you didn't think was necessary. Kathy's husband is an avid outdoors-man. He lives to hunt, breathes to fish and sleeps to dream about hunting and fishing.

Kathy didn't mind that Dean had this hobby, but they had lived in rental homes for fifteen years, and she wanted a permanent home to raise their children. One day Dean saw a for sale sign on 120 acres of prime hunting ground and he was certain it had his name written all over it. By the time he got home he was ready to take out a loan to purchase the land.

Kathy was preparing dinner when she saw Dean strolling across the yard and she could see he was excited about something. She had seen this walk and body language many times over the years and she knew to prepare herself for whatever he had to say. As he blurted out his potential plans, Kathy felt like throwing her spatula at him.

What did this man think he was doing? She had just re-nailed trim to the wall, and stuffed newspaper into the cracks of their windows to keep the cold out. The dryer was on its last leg, and she was cooking his dinner on a cracked stove top of which only two of the burners worked. And he wanted to buy hunting ground? Really?

She white-knuckled the spatula and hollered in her head, "Jesus, hold me back!"

Maybe it was because she couldn't get a word in edgewise over his excitement, or maybe the Lord took away her ability to speak or move her facial muscles for a good five seconds, but Kathy restrained herself from throwing the spatula and his dinner at him. She did however, give the dish a few extra dashes of pepper.

As she listened to her husband's excitement and saw the sparkle of dreams in his

eyes, she knew she was called to one thing in this moment: do not bust his bubble. Don't squish his dreams or begrudge him for having them.

Now, what Kathy did here may not have been noticeable to her husband, but it was blazed across the sky in florescent orange for the Lord. She had learned the vital principle of building others up and had trained herself to apply it to her marriage. She understood that just because she doesn't always see things the way her husband does, doesn't mean she can't support his dreams or his goals. It's called putting others first. And Kathy lived it out, even while squeezing the logo off her utensil.

She could have thrown a fit, which would have escalated into an argument that ruined the whole evening. Instead she controlled her impulses. So often we think of self-control as being a physical action, but more frequently it is required in the basic guarding of our words. Psalm 141:3 asks the Lord to set a guard over our mouth and keep a watch over the door of our lips. Proverbs 21:23 reminds us that guarding our mouth will guard our soul from trouble.

Kathy did just that. She kept her marriage from having to bear the strain of words that could harm it. Dean never did buy that hunting ground, and she was able to keep her husband from feeling belittled or insignificant for having his hopes and dreams for their future. She wisely sidestepped causing tension between herself and her husband by practicing self-control.

Could you use a bit more command over your responses and attitudes? Ask the Lord for it. Self-control is one of His characteristics, so ask Him to impart you an extra measure or two today. Pray for His hand over your husband in the matter, as well. Pray that you and your husband both may grow in this area of self discipline so that you may lead blameless, hospitable, good, upright, holy and disciplined lives.

Verses to Reflect Upon

"So then let us not be like others, who are asleep,
but let us be alert and self-controlled."

1 Thessalonians 5:6

"Therefore, prepare your minds for action; be self-controlled; set your hope fully
on grace to be given to you when Jesus Christ is revealed."

1 Peter 1:13

Proverbs 16:32

Proverbs 29:11

Titus 1:8

Titus 2:12

Prayer

Father God, I come before You, thankful for this man You have put in my life, this man You have called me to love, honor and help. I thank You that You have made him a man able to discern right from wrong. You have given him the power and ability to say "No" to temptations. Help him see where practicing more self-control would benefit his life. Keep renewing his mind, enlightening him, showing him Your will and Your way.

Father, as the leader of our marriage and family, I pray my husband would be a workman worthy of what You have called him to do. Remove any traits that are overbearing or quick tempered, may he not be given to drunkenness, violence, or pursue dishonest gain. In their place, restore hospitality; make him good, self-controlled, upright, holy and disciplined. Help him hold firm to Your trustworthy way (Titus 1:7-9).

Lord, we know our enemy, the devil, prowls around like a roaring lion looking for someone to devour (1 Peter 5:8). Today, I stand against his wicked schemes to make my husband fall. I proclaim that my husband, strong and in the power of Your might, can resist the plans of the evil one.

Father, I pray my husband will not be as some who sleep, spiritually speaking, but that he may remain alert and self-controlled, putting on faith and love as a breastplate and the hope of salvation as a helmet (1 Thessalonians 5:6-8). I pray that You would strengthen and uphold my husband making him able to resist the darts of temptation fired at him.

Jesus, You are the perfect example of a man who is clear minded and self-controlled. Teach my husband to be the same: temperate, worthy of respect, faithful, loving and patient, doing what is good, showing integrity in all he does by his seriousness and soundness of speech. May those who oppose him be ashamed because they can find nothing bad to say about him. Through Your great grace, teach him to reject ungodliness and worldly passions, and to clothe himself with self-control, living an upright and godly life. In Jesus' name, Amen.

Specific Prayer, Praises and Convictions

Fasting Challenge

Fast from sugary
foods and drinks.

Record them:

Other fasting choice:

Day 17

Seeking Wisdom

Often quoted when speaking of a wife's role, Proverbs 14:1 simply states, "A wise woman builds her house, but with her hands the foolish one tears hers down."

Now, while a woman could literally build her house, that is not what this verse is talking about. The building of the house a woman does is in the hearts of those who dwell in it's rooms.

She's the one who watches day and night that her loved ones are fed, comfortable, clothed, lavished with love, spoken kindly to, and taught right from wrong. She teaches them to resolve conflicts peacefully, laugh, sing and play together. She goes from room to room tending to the affairs of her household, making sure everything runs smoothly and harmoniously.

She's helper, healer, gluer, lifter, pillar, rock, nourish-er, soother, peacemaker, organizer, teacher, encourager...*exhausted?!!!* Yes!

Praise the Lord we have a divine blueprint spelled out in His Word which offers help and wisdom when the nails and foundations for your home get shaken. The book of James says all we need to do is ask for it.

In Proverbs we find a few interesting parallels between wisdom and a woman. Proverbs 7:4 encourages us to "Say to wisdom, 'You are my sister' and call understanding your kinsman." Whether you have a sister by blood or choice, you know her value. Her help and support through the tough times is priceless. Her honesty when you'd rather not have it is vital to your growth. God tells us to make wisdom our sister, our go-to girl. You call for her; she's there. You need insight; she's got it.

We also find in Proverbs that both wisdom and a woman of noble character are

more precious than rubies (Proverbs 8:11, Proverbs 31:10). Considering that rubies are one of the rarest jewels known to mankind, it is only fitting that they are mentioned alongside the treasured gift of wisdom and the extraordinary beauty of a noble woman.

Combining these two jewels of wisdom and a woman who fears the Lord, we become like the wife mentioned in Proverbs 12:4 – the one who is a crown to her husband – the perfecting piece, the finishing touch, just as God designed her to be from the very beginning.

Wisdom and a woman should never be separated.

Today, pray for yourself and your husband to be anointed with wisdom. It is possibly the most important thing you can ask the Lord to impart to the man who is your earthly leader. Solomon asked for wisdom in 1 Kings 3:9 so that he could govern his people well. And so, that is what you and I should pray for; that our own husbands would be given a discerning hearts so they may lead their lives and their families well.

Verses to Reflect Upon

*"The fear of the Lord is the beginning of wisdom;
all who have His precepts have good understanding."*

Psalm 111:10

"When pride comes then comes disgrace, but with humility comes wisdom."

Proverbs 11:2

*"Those who are wise will shine like the brightness of heavens, and those who lead
many to righteousness, like the stars for ever and ever."*

Daniel 12:3

*"If any of you lacks wisdom, he should ask God,
who gives generously to all without finding fault,"*

James 1:5

1 Kings 3:9

Proverbs 7:2-4

Proverbs 8:10-11

Prayer

Father, You have promised to give wisdom where it is asked (James 1:5). I ask that You would give my husband a heart that can discern. Help him understand Your word. Give him Your precepts and impart wisdom to him so he may know what is Your good and perfect will.

Father, I pray you will teach my husband to not be wise in his own eyes, doing what he wants, when he wants, or how he wants, but to always seek You first, wanting to please You above man. Help him understand that looking to You first will bring health and nourishment to his body (Proverbs 3:7-8).

Father, we know wisdom is found in those who take advice and accept instruction (Proverbs 13:10, 19:20). Make my husband one who is capable of accepting advice from others. Do not let him be so set in his ways that he will scoff in the face of others who mean well, rather let him thoughtfully and patiently consider their words. Let him not become angry and defensive, speaking harsh words that prove his heart is set in his own ways. Anoint him with wisdom and reveal truth even when it's not what he wants to hear.

Father, deepen my husband's desire to grow in Your word. It has been said, the holy Scriptures are able to make you wise (2 Timothy 3:15). I ask again that You would impart great wisdom to him, so he may lay a foundation of faith for generations to come. Help him be strong, and show himself a man, observing what You require and then walking in Your ways (1 Kings 2:2-4). Help him act justly, love mercy and to walk humbly before You, our unchangeable, infallible, sovereign Lord (Micah 6:8). In Jesus' name, Amen.

Specific Prayer, Praises and Convictions

Fasting Challenge

Fast all meats.

Record them:

Other fasting choice:

Day 18

Developing Integrity

Wisdom and integrity are characteristics I pray for over my husband and children daily. While wisdom will help them *know* what is right; integrity will help them actually *do* what is right.

Putting these two qualities together, we produce a character of prudence, which is defined by Merriam-Webster Dictionary as having *the ability to govern and discipline oneself by the use of reason.*

Prudence is a word we continue to hear less and less. It is rapidly declining from our vocabulary, possibly because it doesn't sound as attractive as others. However, what is much more concerning is the fact that the moral qualities associated with prudence are also vanishing from our society.

Traditionally, prude character it was associated with wisdom, integrity, usefulness, and other things that make up good reputations. Being a prude person means we are capable of good judgment, practice self control, have common sense, and forethought. Prudence falls directly in line with the moral ethics we expect from someone who has the integrity to do what is right and good.

When we look to God's Word, we find quiet a few ideas of what a well-led, prudent life looks like. Ephesians 5:3-5 tells us there must not be even a hint of sexual immorality, impurity, greed, obscenity, foolish talk or coarse joking among God's people. Developing a life of prudence involves ridding ourselves of the old human tendencies and claiming new habits that put Christ on display.

It takes wisdom, which comes from the Lord through His Word and Spirit, to *recognize* the better route. Then it takes a bit of prudence, self control, common sense and even forethought to *decide* how we are going to walk in that better way. Proverbs 27:12 sheds light here by telling us a prudent person foresees danger and

takes precautions. But the simpleton, or immoral person, goes blindly on and suffers the consequences.

Then comes integrity. The point where we actually *walk* on the path that aligns itself with God's Word and will.

A great example of wisdom, prudence, and integrity working together is Daniel. He (1) knew the laws and ways of the Lord, so he (2) decided in his heart that he would not defile himself with the rich foods the king offered. Then, (3) with integrity, he stood for what he believed no matter how silly everyone else thought he was. This story, found in Daniel 1, says that God had caused an official of the land to show compassion to Daniel, and through this man, God enabled a way for Daniel to remain pure before Him.

What we learn is that wisdom must have prudence, the sister of decision, to act in the integrity of faith; then the Lord will fight for us and preserve our lives. Pray to that end for your husband. Ask the Lord that He would give your husband a knowledge of good and evil, that he would judge rightly in his heart which way he should go and then walk boldly on the paths of integrity.

*"The man of integrity walks securely,
but he who takes crooked paths will be found out."*

Proverbs 10:9

*"The integrity of the upright guides them, but the unfaithful
are destroyed by their duplicity."*

Proverbs 11:3

"But the noble man makes noble plans, and by noble deeds he stands."

Isaiah 32:8

*"Similarly, encourage the young men to be self-controlled. In everything set them
an example by doing what is good. In your teaching show integrity, seriousness
and soundness of speech that cannot be condemned, so that those who oppose you
may be ashamed because they have nothing bad to say about us."*

Titus 2:6-7

Psalm 25:21

Psalm 26:11-12

Proverbs 27:12

Prayer

Dear Jesus, thank You for the perfect example of a life of integrity. You did everything with a sincere love for mankind and humble obedience to Your Father. I pray You will reveal Your goodness to my husband and give him the desire to follow in the path You have prepared.

Father, give my husband a heart that is sincere, hating what is evil, clinging to what is good (Romans 12:9). Many are the plans of a man's heart, but I pray, Lord, that the plans of my husband's heart are only noble ones. If the plans of his heart do not fit into Your will or do not line up with Your Word, do not let them come about. Keep him from doing anything that will lead to a guilty conscience or tarnished reputation. May integrity and uprightness protect him (Psalm 25:21). May he always do what is good, be serious, and have sound speech that cannot be condemned (Titus 2:7-8).

Father, I pray you would impart wisdom and prudence upon my husband so he may know and decide what is right. Should he be tempted to do something not glorifying to You, help him stand strong in his faith and walk the way of integrity. May he remember that he who has clean hands and a pure heart will one day have the reward of standing in Your presence (Psalm 24:3-4). I pray my husband will be one who says as Job did, "till I die, I will not deny my integrity" (Job 27:5). May he lead a blameless life before You. In Jesus' name, Amen.

Specific Prayer, Praises and Convictions

Fasting Challenge

Fast all solid foods. Choose
broth, juices, and water.

Record them:

Other fasting choice:

Day 19

Keeping Honest

One of the Bible stories our children have asked for the most is the story of the dishonest tax-paying couple. It could be that our children's interest has more to do with in the vivid expressions, hand-motions, and actions I incorporate into the story, but I prefer to think they enjoy my rendition of the story because it encourages a foundation of truthfulness for their lives. Let me tell you the story:

"One day there was a man and his wife who needed to pay the king a certain amount of their money. Well, these people had to pay a lot of money, and they decided they would trick the king. So the man only took part of what he owed to the tax collectors. They asked him if that was all he needed to pay. And the man said yes.

But the man had lied, and when he turned around, Guess what! (*Insert sharp inhale and bugged out eyes.*)

He fell over and died because he lied. (*Kids express concern.*)

So the people buried him. (*More concern.*)

It wasn't long before the man's wife came along with her bag of tax money for the king. The tax collector asked her if that was all she owed. And she said yes.

But when she turned around, Kerplop! (*Horrified eyes. Sharp gasp.*) She fell over and died because she lied."

This one minute rendition of the story in Acts 5:1-11 stuck with our children and one day, someone lied. The other child, four at the time, caught on and immediately started screaming, "Mom! She's going to die! Make her say she's sorry! I don't want her to die!" Then she sprinted to their bedroom, wringing her hands and started praying frantically that the Lord would not kill her sister for telling a lie.

The one who had lied just stood there, looking at me with fear in her eyes, simply waiting to – Kerplop! – fall over and die.

After the initial drama of the moment, and after everyone understood that nobody was dying that day, I was able to tell them of the grace and forgiveness the Lord offers when we ask.

As comical as this story may be, there are some serious infractions for dishonesty. From cheating on taxes, to using half-truths, to blatant deception, the Lord detests a lying tongue and will not let it go unpunished.

Proverbs 14:5 gives a word picture by saying a false witness *pours out* lies. Other translations say *breathes out* lies. They come out of our mouths and land on all those around us. Anyone who experiences the venom of a lying tongue is left infected because lies and dishonesty reach deep into our soul and nibble away at it in hopes to populate the earth with another liar.

It starts harmless enough – maybe just the stretching of the truth by a fraction. That lie may have resulted in people being impressed or intrigued, and it felt good to be noticed that way. So the next lie grew a bit more bold...and the next...and the next, until suddenly someone caught on and that was the end of their trust in you. And trust once it's broken will never be restored to it's original form.

It's like being found out in a lie really is a death – the death of a relationship. The death of a confidence. The death of innocence. Lying draws a wall between hearts. It causes people to pull away and inflicts grief, sadness, death, and emptiness.

Satan, the father of deception, knows lies and death cannot be separated, so he does his utmost to bait us with the sweet promise of approval from others or anonymity of the lie. But lies are always found out; the truth always prevails. The Father of truth, our Jesus, has triumphed over the enemy and the death he offers, and one day – Kerplop! – that bad dude will fall over into the hell he is promised and all his lies will be brought to light.

As you write out the following verses, ask the Lord impress on you any part of your life that might contain a note of dishonesty. Ask Him to guide you toward a completely transparent and pure life before Him. Pray also that through your upright and honest behavior others may see the beauty of Truth and seek after the Father of it.

Verses to Reflect Upon

"The Lord detests lying lips, but He delights in men who are truthful."

Proverbs 12:22

*"Simply let your 'Yes' be 'Yes' and your 'No' be 'No';
anything beyond this comes from the evil one."*

Matthew 5:37

Leviticus 19:11

Psalm 24:3-4

Proverbs 19:9

1 Peter 3:10

Prayer

Father, we know You do not lie and that You hate all things deceitful. Anyone who practices deceit will not dwell in Your house; anyone who speaks falsely will not stand before You (Psalm 101:7). It is one of the seven abominations and will not go unpunished (Proverbs 6:16). I pray You will remove from my husband any lying or deceptive tendencies. Make him a man who hates dishonesty as much as You do.

Father, I pray You would give my husband the desire to always speak truthfully and sincerely. May he refuse to let deceit spill from his lips. May he keep his oath even when it hurts (Psalm 15:4) because such a man will gain honor and respect. Teach him to let his "Yes" be "Yes" and his "No" be "No" (Matthew 5:37).

I pray he would be a man who is honest in all his dealings. You, oh Lord, detest differing weights and dishonest scales (Proverbs 20:23). Plant my husband in uprightness, so that no one may find fault in his dealings. May the intentions of his heart not be ones of deceit or ill gain.

Father, I pray that You would keep the words of his mouth and the meditations of his heart pleasing in Your sight (Psalm 19:14). May he always keep growing in You, seeking to live a life that is transparent and pure. In Jesus' name, Amen.

Specific Prayer, Praises and Convictions

Fasting Challenge

Fast one meal.

Record the meal:

Other fasting choice:

Day 20

Humility: A Way of Life

It happens to all of us: we mess up and someone offers correction or advice. Maybe it's your husband telling you how to not burn dinner, or your mother-in-law telling you how your mothering is sadly lacking, or some other well-meaning person jabbing an ice pick into your already bruised heart.

As much as it hurts, and as much as we may want to give the other person a piece of our mind, we are still responsible for our own responses. So we get to choose,

- Do we escalate the situation by taking a self protective stance, trying to defend ourselves, possibly casting blame and using angry words?

- Or do we take the criticism, weigh it fairly, seek discernment, and 'fess up where we need to?

I've tried the first option. It gets messy in a hurry. It involves a lot of hurt feelings and bruised egos. I've also tried number two, which is much harder, but it benefits all those involved or observing. It entertains a pliable heart, gentleness, understanding and willingness to seek reconciliation.

The vast difference between the two responses is pride and humility; two complete opposites:

- A proud heart is hard and defensive. A humble heart responds with patience.

- A proud heart is concerned about protecting the person's image or reputation. A humble heart cares more about what God thinks than keeping up a good image.

- A proud heart expects others to apologize and seek forgiveness first. A humble heart initiates reconciliation, no matter how wrong the other may have been.

- A proud heart magnifies others' faults. A humble heart glorifies the Lord for how much it has have been forgiven and grows in compassion toward others through that knowledge.
- A proud heart demands recognition for achievements. A humble heart rejoices in silent victories knowing the greatest achievement is obedience to the audience of One.
- A proud heart is motivated to be "top dog" no matter how many people get hurt on the way there. A humble heart is motivated to stay faithful and pure before the Lord.
- A proud heart is agitated, never letting the situation go because it wants so desperately to be right. A humble heart finds peace in the fact that no matter how sticky the situation, truth will reign and the Lord will use it for good.

How we handle any circumstance is very telling to the condition of our heart, whether it is humble or putrefied with pride. Psalm 51:17 reminds us what kind of heart is pleasing to the Father, "The sacrifices of God are a broken spirit; a broken and contrite heart, O God, You will not despise." The heart spoken of here is not a broken heart like we think of in human terms, rather it is a heart that is pliable to the word of God and has a willingness to learn and walk in obedience to the Lord. This brokenness of heart has a sadness over sin in itself that trumps the need to be right.

No matter how much it hurts, no time of pain or correction is wasted when it produces humility and wisdom. Pray for yourself and your husband to learn to respond from a heart that is tender and gentle towards each other. When humility comes first, peace and wisdom follow shortly behind.

Verses to Reflect Upon

"When pride comes, then comes disgrace, but with humility comes wisdom."

Proverbs 11:2

*"For whoever exalts himself will be humbled,
and whoever humbles himself will be exalted."*

Matthew 23:12

*"Do not think of yourself more highly than you ought,
but rather think of yourself with sober judgment."*

Romans 12:3

Proverbs 15:31-33

Isaiah 66:2

James 4:10

Prayer

Father, we know You hate the proud and love the humble. You have instructed us to not think of ourselves more highly than we ought to, but to think of ourselves with sober judgment (Romans 12:3). Grow my husband into a man who doesn't think himself better than those around him. Give him a heart that is willing to honor others above himself. Let him serve others without ulterior motives, selfish ambitions, or vain conceit; instead let him be humbly and graciously willing to contribute to the good of others (Philippians 2:3-4).

Father, teach my husband to be careful of the words he speaks of himself. You do not find boasting good or of any worth (1 Corinthians 5:6). Your word tells us that whoever exalts himself will be humbled and whoever humbles himself will be exalted (Matthew 23:12). Before a man's downfall he is proud (Proverbs 18:12). Do not let my husband be a man brought to destruction, shame, or disgrace due to boastful words, selfish actions, or a proud heart. Let other men praise him and not himself (Proverbs 27:2). Let other men honor him and not himself.

Father, You have promised to supply meek men with wealth, honor, life, and wisdom (Proverbs 22:4; 11:2). So develop in him a heart that is not proud and eyes that are not haughty (Psalm 131:1). Teach him, even as he sleeps (Psalm 16:7), to be obedient and ready to do whatever is good, to slander no one and to be peaceable and considerate, showing true humility toward all men (Titus 3:1-2). Teach him also to not concern himself with things that seem great and wonderful on this earth, but instead to quiet his soul before You and put his hope in You both now and forevermore (Psalm 131:1-3) In Jesus' name, Amen.

Specific Prayer, Praises and Convictions

Fasting Challenge

Fast all beverages excluding water.

Record the beverages:

Other fasting choice:

Day 21

Courage for the Way

Abigail is possibly my favorite woman in the Bible. She is marked with faith, wisdom and a whole lot of guts. Her story from 1 Samuel 25 describes her and her very wealthy husband in this way, "His name was Nabal and his wife's name was Abigail. She was an intelligent and beautiful woman, but her husband, a Calebite, was surly and mean in his dealings" (verse 3).

It so happened, that previously in the year Nabal's shepherds and sheep camped alongside King David and his army. David's army behaved honorably and did not cause any trouble, nor demand the customary payment of sheep for providing protection to the shepherds and their flocks.

However, when sheep sheering season arrived, David sent a few messengers to collect upon the debt Nabal owed him. Nabal became offended that David would dare ask for a portion of food and hurled insults at the messengers, refusing to give them anything. When David heard of this, he prepared his men and they made their way toward Nabal's home with the intent to destroy all who lived there.

Abigail's servants told her what was about to unfold due to Nabal's pride and stupidity. So Abigail did what any woman would do to protect her home and it's inhabitants; she immediately prepared gifts of food for David and his army. Then, she met them out in the desert where she presented her gifts and pleaded on behalf of her household to bring them no harm. This appeased David's anger, he accepted the gifts and returned to his camp.

Abigail, who had just stood down an army of four hundred angry men, now had to return home to another angry man – her husband, Nabal. When she returned he was drunk, so she waited until morning to tell him what she had done to save his life. When Nabal heard of her actions, his heart turned to stone and he remained in a coma-like state for ten days before he died.

Abigail's story is heralded by many as courageous. Still others argue whether or not she was being a submissive wife by taking matters into her own hands to save her household. But a more pressing question we gather from this story is this: is it okay to go against our husband's authority when it means we obey the Lord?

Abigail knew her ultimate authority to be God. She also knew her husband to be a man who purposely lived in sin. She knew his sin would bring destruction upon those who were entrusted to her care, so she did what any God-fearing woman would do – she protected them from harm.

If there is sin in your home, workplace, church or a friendship, seek the Lord for wisdom in standing for Truth. Do not allow your silence to hold the door wide open for more shame, heartbreak, terror and destruction to enter. Stand for a pure conscience, an open book before the Lord. Hold on to your faith and do what is right in the eyes of the Father.

If you or your husband are facing an army of unknowns and frailty seems to be most prevalent, fall before the Father and ask Him to supply you with strength and audacious courage to stand for what is pleasing to Him.

Verses to Reflect Upon

"Be strong and courageous, and do the work. Do not be afraid or discouraged, for the Lord God, my God is with you. He will not fail or forsake you..."

1 Chronicles 28:20

"Wait for the Lord; be strong and take heart and wait for the Lord."

Psalm 27:14

"Be on your guard; stand firm in the faith; be men of courage; be strong."

1 Corinthians 16:13

Deuteronomy 31:6

Isaiah 12:2

2 Timothy 1:7

Prayer

Father, thank You that You will always be with us to guide us, direct us, comfort us and strengthen us. I pray that You will give my husband an extra measure of this assurance today. Help him be on his guard, stand firm in his faith and be a man of courage (1 Corinthians 16:13). Father, You have not given him a spirit of timidity, but a spirit of power, of love, and of self-discipline. Do not let him be ashamed to testify about You by choosing to stand against evil (2 Timothy 1:7-8).

Father, when my husband deals with difficult people, help him not be intimidated by them. Instead, make him strong and courageous, not fearing or being in dread of them. Remind him often that it is You who goes with him and that You will never leave him or forsake him (Deuteronomy 31:6). May he conduct himself in a manner worthy of the gospel, knowing that You will preserve his life.

When my husband is caught in difficult situations give him courage to do what is right. Help him trust You with all his heart and not lean on his own understanding (Proverbs 3:5). Do not let him grow discouraged. Instead make him willing to walk in ways that please You even when its hard. Remind him that You notice and that You reward Your faithful servant. Make my husband a man of courage who is willing to go the extra mile, do the extra deed, be the extra good. In Jesus' name, Amen.

Specific Prayer, Praises and Convictions

Fasting Challenge

Fast from all electronics.

Record them:

Other fasting choice:

Day 22

Repentance and Forgiving Others

When my groom turned out to be human after all, I did what most human wives do; I started pocketing his offenses and pulled them out whenever I needed to use them against him. This made for some rocky times in our marriage. My broken heart became harder and harder while he became less and less attentive. As a result, we drifted further and further apart.

I cried out to God for help, and He gently showed me that if I wanted to experience joy in our marriage, I would need to forgive more freely. Fact is, I don't do so well with forgiving, and in my opinion, my husband sure didn't deserve it.

The only thing that looked harder than holding on to my bag of grudges was laying it all at Jesus' feet and saying, "Because You have forgiven me and I so appreciate Your grace, I ask that You would teach me how to forgive my husband." But when I did that, little by little my heart was released from the jaws of bitterness.

The Bible tells us it is to our glory to overlook an offense (Proverbs 19:11) and to our honor to avoid strife (Proverbs 20:3). Romans 12 instructs us to to out-do one another in showing honor and to live peaceably among all men as much as it depends on us (Romans 12:10,18). Apply all this to the fact that a gentle answer deflates anger and what we see is that when repentance and forgiveness are practiced continually – as in daily, even multiple times a day – there remains very little room for bitterness and contention to wedge it's way into our marriages.

Is there an area where you find it hard to let God take your pain and anger over things that have taken place in your marriage? Sometimes it is quite eye-opening to see what the opposite side of forgiveness accomplishes, so here are four things holding on to your husband's misdeeds does:

Cultivates bitterness ~ Watering the root of bitterness with unforgiveness will bog

down the marriage relationship in a hurry so "Make every effort to live in peace with all men and to be holy; without holiness no one will see the Lord. See to it that no one misses the grace of God and that no bitter root grows up to cause trouble and defile many" (Hebrews 12:14-15).

Exasperates him ~ It's exasperating to anyone to be around those who pull out our past misdeeds and wave them in our faces like receipts of shame. When a husband lives with the fear that anything he does or says is being deposited into his wife's savings account of injustices, he becomes like the weighted-down man mentioned in Proverbs 12:25 – "An anxious heart weighs a man down, but a kind word cheers him up." Don't frustrate your husband by digging up the past. Start each day with a refreshed resolve to overlook his weaknesses and failures again.

Hinders your prayers ~ First Peter 3:7 speaks specifically to husbands, but the lesson can be applied to all people – "Husbands, in the same way *be considerate as you live* with your wives, and *treat them with respect* as the weaker partner and as heirs with you of the gracious gift of life, *so that nothing will hinder your prayers."* (*emphasis mine*)

Our prayers can be hindered due to the choices we make. When we choose to remain unforgiving we forfeit a life of peace, righteousness and communication with the Father. "For the eyes of the Lord are on the righteous and *His ears are attentive to their prayer*, but the face of the Lord is against those who do evil" (1 Peter 3:12, Psalm 34:15-16 *emphasis mine*). Let's remove the evil work and hindrances unforgiveness brings and claim a life that exudes the power of love and grace.

Puts your love for Jesus up for debate ~ God's Word is loaded with instructions on how to steward our lives. Colossians 3:12-13 advises us to clothe ourselves with compassion, kindness, humility, gentleness, patience and to forgive as the Lord forgives us. Still, we must make the choice whether or not we will do as the Word instructs. With our choice comes the truth of our love for Jesus who says, "*If anyone loves me, he will obey my teaching. My Father will love him, and we will come to him and make our home with him. He who does not love me will not obey my teaching*" (John 14:23-24 *emphasis mine*).

What do your choices say about your love for the Lord?

This forgiving business is hard stuff, I know. But holding on to the past and letting those offenses smolder, will eventually burn a hole of bitterness right through your heart. Then it will stretch it's evil roots out to claw at and consume the hearts of your loved ones as well. Bitterness is never satisfied but you can stop watering it's roots by choosing to forgive.

Pray for yourself and your husband to be moved to repentance, willing forgiveness and reconciliation toward each other. Race to the foot of the cross with any pain and grief your marriage may have today. Lay it all before the Lord and ask Him to cultivate love and understanding toward each other, making your marriage fertile ground for peace to dwell.

Verses to Reflect Upon

"...if My people, who are called by my name, will humble themselves and pray and seek my face and turn from their wicked ways, then I will hear from heaven and will forgive their sin and will heal their land."

2 Chronicles 7:14

"He who conceals his sins does not prosper, but whoever confesses and renounces them finds mercy."

Proverbs 28:13

"I, even I, am He who blots out your transgressions, for my own sake, and remembers your sins no more."

Isaiah 43:25

Proverbs 19:11

Proverbs 20:3

Matthew 6:14-15

Prayer

Father, thank You for Your great mercy. You have shown it to all generations. You are a forgiving God; gracious and compassionate, slow to anger, abounding in love (Nehemiah 9:17). You have promised that when Your people turn from their sins and seek Your face, You will hear them and will be faithful to forgive and heal them (1 John 1:9).

Father, I pray You will give my husband a heart that willingly turns to You. Give him the courage to admit any wrong he may have done. Cultivate in him an ongoing, ever-strengthening desire to do what is good and pleasing in Your eyes. When You convict my husband, Father, also move him to humble repentance, seeing his sin as You do and fully renouncing its hold on his life.

Father, in his repentance give him Your peace so he may might know that he is fully forgiven and may walk unashamedly before You. Assure him that You have removed his sin as far as the east is from the west and that You are the one Who blots out his transgressions and will remember them no more (Isaiah 43:25).

Father, as You have forgiven my husband of any confessed sin, also give him a heart to forgive others. Teach him that he must forgive in order to be forgiven and that You forgive with the same measure he forgives (Matthew 6:14-15). Soften my husband's heart toward anyone who treats him poorly, bearing with everyone in love. Be his Rock when its hard to see past the pain, the unfairness, or the human tendency to seek revenge.

I pray also, Father, that You would heal the land of our marriage of any bitterness, hardness of heart, grudges or contention. Renew in us a willingness to be patient and understanding toward one another. Help us forgive quickly, overlooking offenses and not using them against each other. Heal us Father, and guard us in Your love. In Jesus' name, Amen.

Specific Prayer, Praises and Convictions

Fasting Challenge

Fast from sugary
foods and drinks.

Record them:

Other fasting choice:

Day 23

Trusting God for His Promises

Sometimes it's hard, this trusting thing. Nobody signs up for chronic illness, death of loved ones, marriages falling apart, terminal diagnosis, loss of jobs, and the like. And quite often when life throws messy situations at us, our adam nature kicks in and we get anxious. We cry hot tears. We stress. We worry. We panic. We get angry. Joy dwindles to its bare bones. And if the turmoil in our souls goes on long enough, even our health is affected.

So how do we find the peace and rest that is promised in God's Word? In the midst of all our trials and all our searching, what do we do when all is not well with our souls? How do we learn to trust God for His promises?

If you or your husband are struggling with trust in any areas of your lives, may you find hope and assurance in the following seven promises from the Lord's Word. Taking at look at who He promises Himself to be helps us believe Him for His trustworthiness. Recalling His promises helps us trust that even though our situation may not be ideal, He knows us, He cares for us and He always loves us.

Promise 1: God has a record of keeping His Word. He cannot lie. "God is not a man, that He should lie, nor a son of man that He should change His mind" (Numbers 23:19). What He says, He will do.

Solomon declared that the Lord is trustworthy all those years ago when He said, "Praise be to the Lord, who has *given rest to His people Israel just as He promised. Not one word has failed of all the good promises He gave* through His servant Moses" (1 Kings 8:56 *emphasis mine*). God has a record and it's a good one!

Promise 2: God's very nature is faithfulness, and because of this He can only prove Himself faithful. Even "if we are faithless, He will remain faithful, for He cannot deny himself" (2 Timothy 2:13).

Promise 3: He will never leave us or forsake us. He made us. He put His breath in us. He cannot forget us. His Word promises that even though a mother might forget the child she bore, He will not be able to forget us. "See, I have engraved you on the palms of my hands," He says (Isaiah 49:15-16).

Promise 4: God knows your needs better than you do and before you do. The maker of your soul is "familiar with all your ways" according to Psalm 139:3, so much so that He knows the number of hairs on your head (Luke 12:7).

Promise 5: God is not surprised or baffled by our situations. There is nothing new under the sun. God has seen it all, heard it all, and knows it all. "What has been will be again, what has been done will be done again" (Ecclesiastes 1:9).

Because He can't be shaken by anything, we can go to Him with all our cares and concerns. He is the One who goes before us. He is the One who comes behind us. He is the one who lays His hand over us (Psalm 139:5). In that knowledge, we can trust Him to be our rock, our firm and unwavering foundation.

Promise 6: Nothing is too hard for God. Jeremiah 32:17 says, "Ah, sovereign Lord, You have made the heavens and the earth by Your great power and outstretched arm. *Nothing is too hard for You.*" (*emphasis mine*) Period. Did you see that? It's not a question mark. It's not an exclamation point. It's a period. It's a fact.

Nothing is too hard for God. Hand Him that pain from your marriage. Release your husband to Him. Lift up the wandering child you love. Lay it all at His feet.

Promise 7: He promises consistency; He will never change. He is the same yesterday, today and forever (Hebrews 13:8). He gives us every good and perfect gift, according to our needs, and He *"Does. Not. Change. like the shifting shadows"* (James 1:17 *all emphasis mine*).

If you are finding yourself in the middle of a mess, possibly even a mess you helped create, trust Him to use this time to grow you wiser. Trust Him to use this painful season to help you and your husband emerge stronger together.

Pray for you and your husband to learn to trust the Lord – that you would pour out your sorrows and pains before His throne. Pray that the Lord would saturate His healing into the areas where distrust and grief have been. May the Almighty, gracious Father, teach you and your husband the security He offers through His promises.

Verses to Reflect Upon

"Righteous are you, O Lord, and Your laws are right. The statutes you have laid down are righteous; they are fully trustworthy."

Psalm 119:137-138

"In that day they will say, 'Surely this is our God; we trusted in Him and He saved us. This is the Lord, we trusted in Him; let us rejoice and be glad in His salvation.'"

Isaiah 25:9

"But blessed is the man who trusts in the Lord, whose confidence is in him."

Jeremiah 17:7

Psalm 32:10

Psalm 56:3-4

Psalm 62:5-8

Prayer

Father, we know Your ways are good and perfect. Your word is flawless and You promise to be a shield to those who trust in You (2 Samuel 22:31). Today I pray my husband would be dealt an extra measure of belief. Show him throughout the day that he can trust You with whatever comes. Where there is even a small measure of distrust, doubt, or trepidation, remind him that You have proven Yourself faithful since the beginning of time and You promise to remain trustworthy into all eternity.

Father, when my husband makes plans that go wrong or don't hold out, do not let him become discouraged. Remind him that this is only for a season, and that when he stands firmly on Your solid foundation and does good, You will greatly reward him. Many are the woes of the wicked, but Your unfailing love surrounds those who trust in You (Psalm 32:10). Teach my husband to know that Your thoughts and Your ways are above all others, and that You can not allow what is not fitting to Your great plan (Isaiah 55:8-9). Let my husband rest securely in You and know that Your great and wonderful plans will prevail.

Father I pray You will also make my husband a man who can be trusted. Keep growing him in ways that are honorable so that he may be proven by his good works as a man who is genuine and honest. I praise You, Lord, that You have given my husband a sound mind and teachable heart. Daily, speak to my husband through Your Word and Spirit. Don't let him be like fools who trust in themselves, but rather a man who walks in wisdom, his confidence secured in You (Proverbs 28:26, Jeremiah 17:7). In Jesus' name, Amen.

Specific Prayer, Praises and Convictions

Fasting Challenge

Fast all meats.

Record them:

Other fasting choice:

Day 24

Hearing the Lord

Recently I watched my daughters ignore their three-year-old brother as he threatened to charge at them like a mad bull, head down, eyes squinted, nose wrinkled, his right foot pawing at the hardwood floor. He looked the picture of harmless terror, and his sisters weren't phased a bit.

They managed to stay composed as the little bull began snorting and blowing hot air out of his nostrils. They barely blinked as he took one three-inch leap at them, hoping to get them to yield their stance.

Suddenly, the tiny bull uttered forth a roar of lion-sized caliber, bared his teeth, sprouted finger claws and charged. His prey then took off squealing and diving for cover. One climbed a tree, to which he barked at a few times. The other hopped on her bike, and he gave chase in his battery car while making siren sounds. His mission was soon abandoned as she lapped him around the lane a few times.

My smile turned to deep thoughts as I mulled over the many times I've ignored the Lord's call or warnings until He jolted me to attention. I also recalled the times I bolted and ran the other way and how He had to come rescue me from my miry pit- all because I refused to heed His warnings. Oh, I heard Him all right. I just chose to stuff cotton balls in my ears and sing like a school girl, "La-la-la, I can't hear You."

Sometimes it was carelessness that made me reject His call. Other times it was fear – the fear of what others thought, the fear of making the wrong choice, the fear of failing, even the fear of hearing wrong. All those fears can be legitimate concerns but should never so be so paralyzing that we become immobile. Fear is not from the Lord. Neither does He call us to do something then leave us to figure it out ourselves. What He brings us to, He walks us through.

What do you hear the Lord calling you to today? Maybe it seems like a small thing,

something that will go unnoticed. Or possibly it's as simple as thanking your husband or sweeping the floor. If the Lord is calling you to it, it's not small in His eyes. Do it with joy, as to the Lord and not to man.

Pray for yourself and your husband to hear the Lord in both the grander things of life and the mundane everyday routines.

*"The heart of the discerning acquires knowledge;
the ears of the wise seek it out."*

Proverbs 18:15

*"Like an earring of gold or an ornament of fine gold is
a wise man's rebuke to a listening ear."*

Proverbs 25:12

Matthew 7:26

Mark 4:20

James 1:22

Prayer

F ather, I praise You for the wisdom that You willingly pour out to those who ask (James 1:5). Today I pray my husband will not only ask for and seek wisdom, but that he may hear from You clearly and correctly, also. May his ears be opened, always inclined to hear Your word; then may he do as You ask.

Jesus, You have said, "But everyone who hears these words of mine and does not put them into practice is like a foolish man who built his house on sand" (Matthew 7:26). May he never be as those who hear Your word yet never do as it directs. You have not given my husband a heart that cannot be molded and taught, nor ears that cannot hear Your Word. Remove all foolishness and self-centered tendencies, and replace them with attitudes of love and growth.

Father, open my husband's ears to good instruction, knowledge, and sound teaching. Open his ears to words of rebuke, correction and chastisement as well. While receiving such words is never easy, it is necessary for growth. Give my husband discernment as he gives the words of correction thoughtful consideration. Make all discipline that is from You be like an ornament of fine gold to his listening ears (Proverbs 25:12). Help him recognize advice given in love and take action on anything that needs improvement.

Father, I pray all sound guidance and insight will fall on the good soil of his heart. Help him hear Your words, accept Your words, and produce an abundant harvest through his obedience to You (Mark 4:20). In Jesus' precious name, Amen.

Specific Prayer, Praises and Convictions

Fasting Challenge

Fast all solid foods. Choose
broth, juices, and water.

Record them:

Other fasting choice:

Day 25

Obedience When Called

Jeff heard the Lord calling him to make changes in his personal life and business. He was often harsh with his family and complacent in his faith. He also feared to expand his business where the Lord was calling him to, as well as the extra time investment his obedience would mean. Yet the Lord wanted him to grow in all these areas. Jeff was at a crossroads.

He started having trouble sleeping. He would work all day, go to bed late and a few hours later, he would wake and toss and turn until the eastern skies turned pink. Then he would finally doze off before he had to rise and rush about his day.

This pattern continued for almost six weeks. Jeff tried many different tactics – later bed times, no caffeine, sleeping aids, blackout shades, eliminating night lights – nothing worked. Finally, he sat bolt upright one night and said, "Fine. I'll do it, Lord."

Jeff slept well that night, the next, and every night after that. Some changes he made were immediately noticeable, such as starting family devotions, setting aside time to date his wife, and initiating that business expansion. Other changes were of the internal nature and took more time and effort to retrain his attitudes and thought processes.

Today, however, Jeff is an engaged husband and father who continues to grow in his faith. And that business expansion he made? Well, that has turned out to be the best move of his career.

He heard the Lord. He answered the Lord. But more importantly, he *obeyed* the Lord. And through all the difficult changes Jeff walked through, the Lord doused him with an extravagant amount of grace.

Are there any specifics the Lord is calling you and/or your husband in obedience to? Jot them down and pray for the strength to do so.

Verses to Reflect Upon

"Preserve my life according to Your love,
and I will obey the statutes of Your mouth."

Psalm 119:88

"Jesus replied, "If anyone loves me, he will obey my teaching."

John 14:23

Deuteronomy 13:3-4

Deuteronomy 30:9-10

Prayer

Sweet Jesus, You are a gentle presence. You are kind. You are patient. You are loving. You are also sovereign and cannot tolerate the sin of disobedience. Prove Yourself trustworthy to my husband that he may learn to love and obey Your commands without hesitation.

Lord, we know You test us to see whether we love You with all our heart and soul (Deuteronomy 13:3-4). Gently test my husband, but do not overwhelm him. When walking through times of testing grant him the peace that passes all understanding, reminding him that he is not alone in this journey.

Father, do not let my husband grow angry at You or weary of Your will. I pray he will obey the commands and decrees You have written to us and that he will turn to You with all his heart and all his soul. When doubt knocks, give him the courage to stand strong and say, "I will obey my God's teaching." Then, in due time, bless him abundantly for his devotion to You.

Father, I pray also that my husband's example of humble obedience will direct the course of his children's lives and many generations after them. Today, freshen his faith and his resolve to serve You and bring his life in compliance with Your will. In Jesus' precious name, Amen.

Specific Prayer, Praises and Convictions

Fasting Challenge

Fast one meal.

Record the meal:

Other fasting choice:

Day 26

His Spiritual Leadership

Leading his family spiritually is intimidating for many men. A few of the ways the Church encourages husbands to take on their role as spiritual leader is by suggesting they read and study their Bibles for an hour a day and have twenty-minute prayer times. They are encouraged to have half-hour devotion and worship times with their families, and pray with their wives for fifteen minutes a day, just to name a few.

Marcy watched her husband, Andrew, resolve many times to lead his family in some of the recommended ways. And she watched him fall flat many times. As a result, Andrew became discouraged, defensive, and frustrated. He felt like he didn't measure up to other men in the church body who seemed to have it all together. Then he started feeling intimidated by his wife's faith because she seemed much more spiritual and fluent in the Bible than him.

At first, Marcy was disappointed in his shortcomings in this area. She never voiced it, but she wished he would, you know, "step it up". "Just get out that Bible and start reading out loud. How hard could it be?" were her thoughts.

As one thought built on another, Marcy ended up a little indignantly with this, "Why should I submit to my husband if he can't lead the way he's supposed to?"

That's when her spiritual brake lights came on.

She recognized the ugly roots of bitterness and contention for what they were and brought her case before the Lord for Him to search her heart. There the Gracious Father started impressing a few things on her heart. He reminded her that while her husband's spiritual leadership doesn't always look the way she wants it to, she is still responsible for own actions in her marriage and home. Then He gave her wisdom and strength to know how to respond in appropriate ways. This opened conversations and

growth between Marcy and Andrew as well as strengthened their diligence in seeking the Lord.

Marcy's commitment to honoring her husband even when he didn't lead the way she wanted him to, encouraged Andrew to take baby steps in growing his faith to overcome his feelings of inadequacy and intimidation.

Today, Andrew reads the Bible to his family more consistently and he prays with his family and wife more often. At times life throws it's curves and routines get rearranged, but always he picks up his role and continues to try.

If your husband is struggling in the area of spiritual leadership, these following four points might help you regain perspective as they did for Marcy.

1. *When your husband doesn't read the Bible to his family, you can.* Part of motherhood means following the instruction found in Deuteronomy 11:19-21 as best as you can.

> *"Teach them to your children, talking about them*
> *when you sit at home and when you walk along the road,*
> *when you lie down and when you get up.*
> *Write them on the door-frames of your houses and on your gates,*
> *so that your days and the days of your children may be many..."*

You can teach your children God's Word. You can talk about God's Word, pray God's Word over them and put God's Words on your walls. There is no arguing that having Daddy read the Bible has a huge impact on children, but what Mommy teaches them has just as much influence. So teach them diligently.

2. *If your husband is not as well versed in the Bible as you are, that doesn't make his faith or his leadership defunct.* Everyone meets God in different ways and has been given different measures of faith. None of those differences disqualify anyone's current walk with Christ.

3. *Consider that your husband may not have been given a healthy model of how a husband should lead.* Whatever example your husband had or didn't have can play a huge role in the way he leads his own marriage and home. Continue to encourage his efforts and pray that he would be guided toward better leadership examples.

4. *Remember it's not scriptural to expect your husband to lead in ways that work for other men.* No, it really isn't. Our goal should not be to have a strict outline of what our husband needs to do before he qualifies as a leader. He needs to nourish a

relationship with God first so he can lead through the way the Spirit leads him. Let's not get in the way of that.

Let's pray our hearts out, show our husbands a little bit of Jesus through the way we live out our calling as a wives, and expect God to do greater and mightier things than we dare hope for.

Verses to Reflect Upon

"Love the Lord your God with all your heart and with all your soul and with all your strength. These commandments that I give you today are to be upon your hearts. Impress them on your children. Talk about them when you sit at home and when you walk along the road, when you lie down and when you get up."

Deuteronomy 6:5-7

"The fear of the Lord leads to life."

Proverbs 19:23

Proverbs 17:27

Mark 10:43-44

Prayer

Father, I praise You for the wisdom You have given my husband. Teach him to love Your Word more and more so that he will be able to lead his children in the same way.

Where spiritual leadership was not modeled to him, provide godly role models for him to fashion his life after. Teach him through Your Word that true leadership is pure and kind, not harsh or demanding. Impress upon him that a great leader will not try to "lord it over" or force his will onto those around him. Whoever wants to become great among people must be a servant or helper to all. Deepen his desire to portray Christ, who came to serve and offer up his life for others (Mark 10:42-45).

Father, strengthen my husband's faith so that he may lead diligently. Keep him rooted and built up in Christ, overflowing with thankfulness to You. Teach him to weigh all matters, and see to it that no one takes him captive through hollow or deceptive philosophy. Enlighten him so he will know what the vain, human traditions and principles of the world are rather than the teachings of Christ (Colossians 2:6-8).

Father, do not let him be intimidated by the call You have given him as spiritual leader of his home. Rather, give him the courage, ability, and ease to talk about Your words while sitting at home, walking along the road, lying down or getting up (Deuteronomy 6:6-7, 11:18-21). I pray that You would give him a renewed burden to train his children in the way they should go so that when they are old they will not depart from it (Proverbs 22:6).

Father, I pray my husband would stand strong in the power of Your might. The fear of You, oh Lord, leads to life. Do not let him stray. Should he grow slack, pursue hard after him. Do not let him wane in his faith but keep him always prepared to do what you require. May Your ways and what is edifying to growth be what comes out of his mouth first. May he lead with wisdom, integrity and servant-hood in his home, workplace, friendships and marriage. In Jesus' precious name, Amen.

Specific Prayer, Praises and Convictions

Fasting Challenge

Fast all beverages excluding water.

Record the beverages:

Other fasting choice:

Day 27

Purposeful Fatherhood

Sadly, the past twenty-some years of rapid growth in technology, have somehow manipulated us to trade family ties for computers, televisions, i-phones and i-Pads.

However, children don't come out of the womb expecting to see our eyes and attention averted to some sparkly yet cold, lifeless box. It's not natural to stare at a screen, hide behind a computer or even a newspaper. It's not okay to virtually leave our homes while we are sitting in them. Yet that is what happens when we mindlessly surf the web or give our undivided attention to an object rather than the occupants of our home.

One mother decided to take note of the number of times her two-year-old looked at her. For ten minutes she tallied his every glance in her direction as he played happily with his blocks. A whopping twenty-eight times he turned his eyes toward her. Twenty-eight times he was reminded that his mother cared enough to notice him. Twenty-eight times he knew his mother was present and engaged.

What if, for those ten minutes he would have seen his mother's eyes glued to a screen, completely ignoring him?

Furthermore, how many ten minute time segments slide by that our own children start wondering when we are returning home from the object that has overtaken our attention?

Recently I wrote a letter to both the mom on social media and the dad on the couch. It was a plea on behalf of children for mothers and fathers to be more engaged with their children.

This letter is a sobering look into how quickly life passes. Let's take advantage of every moment. Let's look deeply into our children's eyes. Let's listen to their every

concern even when it's small potatoes compared to our adult lives. If we don't train them that we are a safe, nurturing place for them to bring their issues to, they will take their problems elsewhere; food, drugs, alcohol, pornography, and unhealthy relationships to name a few. Do not enable your children to fill your spot in their lives with someone or something that could bring more harm than good.

Right now pray for yourself and your husband to have your eyes opened to anything you may need to change in the parenting department. Jot down what the Lord is laying on our heart, then specifically pray for wisdom and strength to do as He directs.

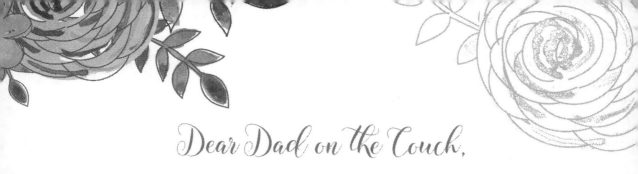

Dear Dad on the Couch,

I get it. Your day was busy. You had many things to do. It feels good to sit down a bit and let the TV think for you. Your wife brings you a cold drink, and you relish the feeling of being cared for.

Then your child bounces in. He has a ball and wants you to come outside to play. You say, "No, I'm too tired." Your eyes remain glued to the screen. He walks away, dejected. Another child is singing to herself while coloring in the chair beside you. You snap, "Quiet, I can't hear my TV." She curls up in silence, no longer finding joy in coloring a picture for you.

Still another leaps in front of you striking a pose in his superhero cape. You frown and growl, "Move, I can't see my TV." You didn't know he had worked all day, hand sewing his cape and constructing his cardboard and duct tape sword with care. He walks away with head hanging and shoulders sagging, saddened that his own hero was unpleased.

Dad, I know you're tired and you need to unwind, but you won't remember your best day of TV. Your kids will, though.

They'll remember seeing your disapproving face that favors the view of the screen. They'll remember hearing your rude impatience. They'll remember your snide remarks as you prefer the virtual over the real.

They'll remember Daddy had no time and found them to be an inconvenience.

Dad, I know you're tired. You'll get a chance to rest without interruption after you've poured into their lives more than just providing food and a home. They need your voice to cheer them on. They need your deep rumble as you pray over them and feel your whiskers as you kiss them goodnight. They need your strong arm steadying them as they teeter on their bikes.

They need to see you smile and nod, listening intently as they describe their latest adventure. They need your shoulder to cry on when life is too much and a little pep talk to help them stand for what is right.

Daddy, you're their hero.

Their comforter. Their guide. Their encourager. Their safe place. Their strong hand. Their defender.

Their dad. They need you to stay in that high position.

So when you come home tonight, remember as you drive in the lane, your real job has just begun. One day you won't have this job anymore. And you'll look around in the silence and wonder where they've gone.

Day 27 Purposeful Fatherhood

Verses to Reflect Upon

*"These commandments that I give you today are to be upon your hearts.
Impress them upon your children."*

Deuteronomy 6:6-7

Proverbs 22:6

Isaiah 40:11

Ephesians 6:4

Colossians 3:21

Prayer

Father in heaven, thank You for a beautiful picture of what true fatherhood looks like; not harsh yet commanding respect, not demanding yet expecting obedience, not irrational in ways that exasperate Your children but always loving, always kind, and ever gracious. Give my husband Your heart toward his children. Make him a man who communicates unconditional love to them. May they always know their father loves them and does all that he does for their good.

Help him be patient with his children, Father. Show him the grace You have covered him with so that he may, in turn, extend grace to his children. When he feels impatient, help him rise above the immediate circumstances, enabling him to speak and respond in ways he won't regret. Help him speak with calmness and authority, never letting his children doubt his love for them.

Father, show my husband where he can cultivate a deeper relationship with each child. I pray he will not be cold, harsh, uninterested, undependable, or neglectful. May he never provoke his children to wrath but bring them up in the training and admonition of You, Lord (Ephesians 6:4). Help him be present physically and emotionally, not being ruled by what he might deem of greater importance right at that moment.

Where he feels inadequate to teach his children Your ways, give him courage and the ability to speak what they need to hear. Help him communicate Your ways to them. May the knowledge that their father loves the Almighty have a profound impact on their lives.

Father, we know You discipline those You love (Proverbs 3:12). You do it with great love, mercy and the desire to grow us up in You. When disciplining his own children, help my husband do it calmly, justly, and lovingly, never in anger, irritation or self-righteousness. Help him be a fair judge, not dealing with them in haste.

Father, I pray you will teach him, guide him, and direct his paths in this role of fatherhood. May it be one of great fulfillment to him, and when he is old and gray may he rest, knowing he obediently left a rich spiritual inheritance for his children. In Jesus' precious name, Amen.

Specific Prayer, Praises and Convictions

Fasting Challenge

Fast from all electronics.

Record them:

Other fasting choice:

The Labor of His Hands

A man's work is a source of identity and fulfillment for him. When he enjoys his work and does it well, he finds great purpose in life. Having a wife at his side who thanks him for his efforts and praises his abilities, helps him stay motivated to pursue dreams and goals.

God wired the male population to protect and provide for their own. This may vary according to the seasons and abilities of each individual. However, for most men, this drive to protect and provide (call it testosterone, if you will) is trumped only by the fear of not being able to do so.

When the fear of failure becomes a man's motivation, he is easily drawn into workaholic-ism. He becomes the kind of man who is never at home, misses his kids ballgames, is absent from birthday parties and family outings because he is so concerned about his next business deal.

The workaholic doesn't intend to neglect his wife and family. He simply sees his long hours and weekend shifts as his greatest effort to fulfill his inner, unspoken, often unrecognized fear of being incompetent of providing for his family. Nevertheless, the life he is working so hard to build slips by and, in many cases, slips away in a broken home.

The opposite extreme of a workaholic is the man whose rear wears a pronounced groove in the furniture. This lazy man still has the drive to provide and protect, but he's become a bit out of tune with it. I've heard lazy men carelessly quote, "Do not worry about tomorrow, for tomorrow will worry about itself" (Matthew 6:34). While that is true, 1 Timothy 5:8 holds the reminder that if anyone doesn't provide for his family, he is worse than an unbeliever. Throwing his family's well-being to the winds of happen chance is not acceptable in God's eyes.

The wife of a lazy man can either help motivate him by planting seeds of encouragement into her lazy husband's heart, or she can make his groove in the couch even more comfortable by constantly nagging and complaining.

For example, one wife started a project, then asked her husband to show her how it could be done better. She called him out on his manhood, and he was motivated to prove his capabilities. Those little seeds of encouragement were like peas in the groove of his couch, rubbing and chafing until he became driven enough to overcome laziness and work on providing for his family. What started as little projects and odd jobs around the neighborhood eventually evolved into a flourishing business in woodworking.

Both these men, the workaholic and the slacker, bring ruin to their families and homes through their lack of proper leadership. So, pray for your husband to have a healthy balance between work and rest.

Verses to Reflect Upon

"Be strong and courageous, and do the work.
Do not be afraid or discouraged, for the Lord God, my God, is with you.
He will not fail you or forsake you..."

1 Chronicles 28:20

"Commit to the Lord whatever you do, and your plans will succeed."

Proverbs 16:3

"Whatever you do, work at it with all your heart,
as working for the Lord and not for men..."

Colossians 3:23

1 Thessalonians 4:11-12

1 Timothy 5:8

Prayer

Father, bless my husband's work. Thank you for giving him the abilities to do the work You have called him to. Help him find a proper balance between working too much and being too lazy to take on his responsibilities.

Father, I pray he may work with his own hands so that he will not grow completely dependent on anybody (1 Thessalonians 4:11-12). I pray he will make it his ambition to lead a quiet and simple life so that his daily work may win the respect of outsiders. Teach him to bring You into every aspect of his work. Where there is anything not glorifying to You, convict him, then supply him with the courage to make any necessary changes. Teach him to commit whatever he does to You, so his plans may succeed (Proverbs 16:3).

Lord, I know so much of a man is tied up in his work. Give my husband a sense of fulfillment from the labor of his life. "Nothing is better for a man than to enjoy his work, because that is his lot" (Ecclesiastes 3:22). Give him clear direction of Your plan. Help him to see past the dollar signs and rest secure knowing that Your provision will always be enough.

Father, I pray for the individuals You bring into my husband's life through his work. May they be people of integrity who encourage and strengthen his walk with You. Guide my husband away from anyone or anything that could harm his livelihood. You guide the hearts of kings like a stream (Proverbs 21:1), so I know You are capable of steering my husband away from bad business deals, jobs, or influences that could rob what he has worked for.

Father, help me to not come in the way of Your will regarding my husband's work. I confess the times I haven't been supportive or appreciative of him. Help me accept his job, knowing You are in control, guiding and prospering his efforts. You have promised hope and a future for us and our family, to prosper us and not to harm us (Jeremiah 29:11). I firmly hold on to that promise. Give me words that will encourage and affirm even when I struggle with his calling.

Father, lead him, guide him, and direct him. Then surround him, encourage him, and enable him to do his life's work humbly, willingly and thoroughly. May he be strong and courageous, willing to do the work you call him to. In Jesus' name, Amen.

Specific Prayer, Praises and Convictions

Fasting Challenge

Fast from sugary
foods and drinks.

Record them:

Other fasting choice:

Day 29

Handling His Finances

Matt had a poor paying job. He could barely make ends meet. Then, times got harder and he lost his job. As he looked at his wife over their meager dinner of salted noodles, he said, "Hun, we are down to our last twenty dollars." She nodded and forced a quiet, tired curve representing a smile and said, "We'll be all right. We've tithed faithfully, no bills are due for another two weeks, and we have food enough for a while."

Matt lowered his eyes to his plate but not before his wife saw the fear in them. That evening as she laid next to her sleepless husband, she wondered how in the world she would be able to tell him baby number three was on its way. She lifted a tired, yet sincere prayer, "Lord, You're going to have to show up."

The next day held more of the same noodles and quiet strength her husband needed to see. Then, they heard of a neighbor who needed help, and her husband went to lend a hand. An hour later the task was completed and a conversation started between Matt and the neighbor. As God would have it, their dialog turned into a job offer complete with a month's pay in advance.

The check Matt brought home that day was enough to cover all their monthly bills and groceries.

That wasn't the last of their financial struggles, but it was a huge lesson in trusting God for provision. Today, Matt has a thriving business, and finances are not as scarce as they once were. Still, the lesson in faith all those years ago makes them all the more thankful for the abundant blessings they have now, and all the more faithful in how they steward and share those blessings.

If your marriage has the extra stress of financial lack, the enemy would love nothing more than to tear you apart by pitting you against each other. Throwing around

accusations of careless spending or justifying an unnecessary shopping spree with your spouse's latest "good deal" purchase from the clearance isle, will only escalate the issue. Take responsibility for your own actions and repent where needed; then encourage your husband to do the same.

As provider of his home, Matt already felt like he was failing. His wife knew she had the unique power to either dishearten or encourage him. Why add insult to injury? Why take the last little dose of courage he had and stomp all over it? Being a strong, gentle place for him at one of his most vulnerable moments was a balm to his bruised spirit.

Pray for your husband in the area of finances often. Money has a way of ruling people. The lack of it makes people fearful, and an excess of it ruins people and brings them to bankruptcy, arrogance, complacency, and hardness of heart. Pray for a healthy, needed amount of money to provide for your family. Then pray for wisdom to know how to use it appropriately and also to further God's kingdom.

Verses to Reflect Upon

"Humility and the fear of the Lord bring wealth and honor and life."

Proverbs 22:4

"A faithful man will be richly blessed, but one eager to get rich will not go unpunished."

Proverbs 28:20

"Whoever loves money never has money enough; whoever loves wealth is never satisfied with his income."

Ecclesiastes 5:10

Psalm 49:20

Psalm 62:10

Malachi 3:10

Prayer

Dear Jesus, thank You that You have provided an income for my husband. Through his work, You have always provided enough. Sometimes just enough, most times more than enough. But always, enough.

I pray now that my husband will choose wisely how to spend the money You have blessed him with. Show him where unwise spending needs to be eliminated, so finances can be freed up to pay for necessary things. May he spend his money carefully and with foresight so that he and his family will not perish (Psalm 49:20).

Father, remind him to bring the whole tithe into the storehouse before he spends Your money elsewhere. You have promised that when we are faithful in returning to You what You ask, You will throw open the floodgates and pour out so much blessing that we will not have room enough for it all (Malachi 3:10).

Father, create in my husband an honest heart when it comes to earning money. I pray You will far remove any thought or consideration that will lead to extortion, stealing, or dishonest financial gain in any way. May he never bring punishment upon his own head or his family by being eager to get rich (Proverbs 28:20). Remove from him any tendency toward greediness or selfish financial advancement, and replace it with contentment and satisfaction with what You have provided.

Father, with any extra money, give my husband a desire to bless others and give freely from the overflow. Don't let him become reckless or selfish with his money. May he always know that You are the Provider and Giver of every dollar, dime, and cent. While his finances may increase or remain stable, may he never set his heart on them (Psalm 62:10), but rather count his wealth in things that cannot be bought. In Jesus' name, Amen.

Specific Prayer, Praises and Convictions

Fasting Challenge

Fast all meats.

Record them:

Other fasting choice:

Day 30

Protection for the Day

As I watched my children take turns riding on their daddy's shoulders, I could almost feel the rocking motions and the butterfly sensations go through my own stomach, just as they did when I was a child. They reached out their arms, pretending to fly, then grabbed his face as he dipped and swayed a bit too far for their comfort. Then, straightening out, they resumed their precarious perch with confidence in their father's strength and ability to carry them.

In the midst of the laughter and fun, I am struck by their trust. They are quite vulnerable up there, really. They feel the wobbliness, the unstable movements of daddy's shoulders, the unpredictable bouncing. Yet they are completely secure in the knowledge that their father wouldn't let them fall or topple from their lofty position.

I'm reminded of Deuteronomy 33:12 which says, "Let the beloved of the Lord rest secure in Him, for He shields him all day long, and the one the Lord loves rests between His shoulders."

In this world, we are promised troubles. However, through the sways and dips the courses of life bring our heavenly Father remains – our stronghold, our stable foundation, our security, our trust and protection. We have the promise that He will hem us in behind and before, and keep His hand over us (Psalm 139:5). So even while we are exposed to life's tragedies, we are held secure in the knowledge that He knows, He sees, and He cares. He will not leave us destitute.

As I watch my children on their father's shoulders, I am reminded that we are vulnerable to the winds of life, yet on the Lord's shoulders, we find a windbreak.

In the midst of the scorching heartbreak death and sin can bring, His love provides a cooling, peaceful rest.

When the fiery darts of the enemy barrage our souls, the Lord, our fortress and shield, never wavers.

On His shoulders we are still vulnerable to all kinds of sleet and hail, floods and blizzards, droughts and famines of life. But on His shoulders He is teaching us to trust Him as our firm, unwavering, ever-stable foundation. Our protection and help. Our faithful Father.

Pray today for the Father's hand over you and your husband. Pray for His watchful eye to be on you, guiding you both out of harms way in your daily commute, work, health, and your spiritual well-being. Pray that even in the chaos and insecurities of this earth He would keep you 100% secure in His love and care.

Verses to Reflect Upon

"The Lord redeems His servants;
no one will be condemned who takes refuge in Him."

Psalm 34:22

"If you make the Most High your dwelling…then no harm will befall you,
no disaster will come near your tent. For he will command His angels concerning
you to guard you in all your ways."

Psalm 91:9-11

Psalm 18:1-3

Psalm 91: 1-2

verses 14-16

Psalm 121:7-8

Prayer

Father, I thank You for the promises of safety You give throughout the Bible. You give us refuge. You are our Strength and Redeemer. Thank You that You will never leave us nor forsake us and that You will be gracious to us all the days of our lives.

Father, protect my husband in all the ways he walks; watch over his coming and going (Psalm 121:8), guiding him away from any harmful situations. Protect him from traveling accidents, work accidents, sicknesses, and harmful diseases of the body or mind. Protect him from violence and the people who do it. Lord, I know that Your arm is not too short that You cannot save (Isaiah 59:1). Preserve the life of my husband so that he might grow old to watch his children's children grow. I entrust him to You, fully convinced that You are able to protect him today and every day of his life (2 Timothy 1:12).

Father, when his heart is burdened and the world seems dark all around him, remind my husband that You are his shield, his deliverer, and his rock. Remind him that You are his firm foundation, cornerstone and stronghold (2 Samuel 22:1-4). Protect him from any attacks the enemy plans to make on his mind and body by diverting the fiery darts that get sent his way. You will not fail him, for You will not reject Your people; You will never forsake Your inheritance (Psalm 94:14).

Father, I stand in the gap on behalf of my husband (Ezekiel 22:30-31), asking that You ash the blood of Jesus over him and our marriage that we may be protected spiritually and physically by Your great power and love. In Jesus' precious name, Amen.

Specific Prayer, Praises and Convictions.

Fasting Challenge

Fast all solid foods. Choose
broth, juices, and water.

Record them:

Other fasting choice:

Day 31

A Worthy Example

When I read 1 Timothy 6:11-21, I can almost imagine a wild-haired, gruff-looking Paul standing over this portion of the letter and with all the love and concern a parent can muster, adamantly tell the young man how to lead his life.

Paul instructed Timothy to pursue righteousness, godliness, faith, love, endurance and gentleness, and turn away from godless chatter and twisted knowledge. We find a similar list of characteristics in Titus 2 where Paul wrote Titus a "Christian Character Directory" for the different groups of people. The older men are to be self-controlled, levelheaded, strong in faith and love, so that they may teach the younger men to live in the same manner. The older women are to be reverent in the way they live so they may teach the younger women to be self-controlled, pure, kind, loving, and how to thrive in their roles.

These older and wiser generations are to lead their own by being living, breathing *examples,* not just instructors. Notably enough, while these instructions are given to the elderly, each of us are both the older and the younger at the same time. We ought to learn where we need to, yet let our lives set an example for all.

The traits found in the Titus 2 "Christian Character Directory" still apply to us today and are given for the reason that no one will be able to malign the word of God (Titus 2:5). As servants of the Lord, our character reflects upon Him. Far be it from us to fog up His image by living dishonest, self-seeking, stiff-necked, back-sliding lives. Instead, we should be diligent about modeling His character in everything we do, so that by the example of our lives we make the teaching of the Lord attractive to those around us (Titus 2:10).

In other letters Paul wrote, we find the same kind of urgency to live a life that puts Christ on display for all to see. In 1 Thessalonians 4:1, Paul writes, "we instructed you

how to live in order to please God....Now we ask you and urge you in the Lord Jesus to do this more and more."

Today, pray for yourself and your husband to live in ways that exemplify Christ. Pray that your lives may win the respect of those around you and make the flavor of Christ sweet to them.

Verses to Reflect Upon

*"Be imitators of God, therefore, as dearly
beloved children and live a life of love…"*

Ephesians 5:1-2

*"Don't let anyone look down on you because you are young, but set an example
for the believers in speech, in life, in love, in faith and in purity."*

1 Timothy 4:12

*"Do your best to present yourself to God as one approved, a workman who does
not need to be ashamed and who correctly handles the word of truth."*

2 Timothy 2:15

2 Timothy 2:16

verses 22-24

1 Thessalonians 4:11-12

Prayer

Dear Jesus, You have set a perfect example for us to follow; one of love, kindness and humble obedience. Give my husband a desire to fashion his life after Yours, doing nothing out of vain conceit but considering others better than himself. (Philippians 2:3) Remind him often that he has younger eyes watching him, looking up to him for guidance. Outside his home, remind him he has worldly eyes watching and needing an example of purity, goodness, and compassion for mankind.

Father, give him strength and courage to do his best to set a good example. Teach him that setting a respectable example includes watching the words he speaks, avoiding godless chatter, and having nothing to do with foolish and stupid arguments. Teach him that a man of good character sets an honorable standard when he refuses to quarrel, but instead is kind to everyone (2 Timothy 2:24).

Father, I pray my husband will leave a path worthy of following by the way he conducts himself. Remove any tendencies to be quick-tempered, for we know a man of quick temper does foolish things (Proverbs 14:17). Do not let him be foolish; remove any drunkenness, violence, dishonesty or any evil tendencies. In their place, teach him to be hospitable, and love what is good, to be self-controlled, upright, holy and disciplined. Help him live a blameless life, setting an honorable example (Titus 1:7-8).

Father, where my husband may have been less than exemplary, give him courage to repent and do better. I fervently pray that where a godly life has not been modeled to him, You would help him rise above and not fall into the traps of generations past. When he is unsure of the best thing to do, move his heart to dig into Your Word, the only good, right and perfect example for him to fashion his life after. In Jesus' name, Amen.

Specific Prayer, Praises and Convictions

Fasting Challenge

Fast one meal.

Record the meal:

Other fasting choice:

Day 32

The Paths He Walks

Each day we are faced with spiritual intersections. One direction guides along paths of truth and righteousness, while the other invites us to recklessly barrel into selfish desires. Take the Prodigal Son, for instance. He dove headlong onto the path of distant glittering promises, only to find it was a slippery slope that landed him squarely in the undignified stench and mire of a pig sty.

We are given the liberty to choose our steps. Many are the plans of our hearts, the Bible says, but it is the Lord's will that will prevail. In other words, we can choose the wrong path, but the Lord will not condone something that does not align with His Word. We have full reign to boldly walk our own way, but because such a path doesn't appoint the Lord as Guider of our lives, we will always end up in circumstances we'd rather not be in.

The deepest disappointments and pains in my life have come from times when I rearranged my values and priorities so much that I replaced God's agenda with my own. Sadly, God is often viewed as an add-on, a self-help of sorts, rather than our Father, Creator of our souls, Designer of our life, reason for our very breath.

This should not be so.

God should not be reserved to a small corner of our lives where we go to meet Him a few times a week or only once a day. He should not be summoned only when we think He might be of use to us. His presence should be invited before we try to live life on our own. His power should be called upon before small problems become full blown issues, and His whispers heard before we take matters into our own hands.

His Word gives us a few practical ways to be intentional about appointing Him in our days. None of them are revolutionary. Instead, they are simple little things that

fit naturally into our lives, just the way God desires us to know Him – relational, practical, reachable, and consistent.

- **Seek Him early in the morning.** "In the morning, O Lord, You hear my voice; in the morning I lay my requests before You and wait in expectation." — Psalm 5:3

- **Speak of His Word throughout your day.** "Talk about them (His Words) when you sit at home and when you walk along the road, when you lie down and when you get up." — Deuteronomy 6:7

- **Put His Word on your walls.** "Write them on the door frames of your houses and on your gates." — Deuteronomy 6:9

- **Memorize His Word.** "Bind them on your fingers; write them on the tablet of your heart." — Proverbs 7:3

- **Sing His praises.** "Sing to Him; sing praise to Him; tell of all His wonderful acts." — Psalm 105:2

- **Be still before Him.** "The Lord will fight for you; you need only to be still." — Exodus 14:14

- **Refuse to be ruled by past regrets.** "Do not say, 'Why were the old days better than these?' For it is not wise to ask such questions" — Ecclesiastes 7:10

 "Forgetting what is behind and straining toward what is ahead, I press on toward the goal to win the prize for which God has called me heavenward in Christ Jesus. All of us who are mature should take such a view of things." — Philippians 3:13-15

- **Thank Him.** "[G]ive thanks in all circumstances, for this is God's will for you in Christ Jesus." — 1 Thessalonians 5:18

- **Think and meditate on His name as you go to sleep.** "I will praise the Lord, who counsels me; even at night my heart instructs me." — Psalm 16:7

 "In the night I remember Your name, O Lord, that I may keep Your law. This has been my practice: I obey Your precepts." — Psalm 119:55-56

Putting these practices into place will result in a prayerful attitude that we can carry with us wherever we go. Tapping into our reserves of power in Jesus' name through prayer and conversation with Him will guide, direct, and illuminate our own steps and the steps of whomever we pray for.

Do not underestimate the impact your prayers can have over your husband's normal everyday walk. Bind the enemy's plans in prayer and cast them out in Jesus' name. Ask the Lord to steer your husband along the ways that are pleasing to Himself. Pray for your husband to be given direction, guidance, wisdom, and courage to choose the better way at the crossroads.

Verses to Reflect Upon

"Blessed is the man who does not walk in the counsel of the wicked or stand in the way of sinners or sit in the seat of mockers."

Psalm 1:1

"Whether you turn to the right or to the left, your ears will hear a voice behind you, saying, 'This is the way; walk in it.' "

Isaiah 30:21

"His command is that you walk in love."

2 John 6

Psalm 121:7-8

Proverbs 4:26-27

Micah 6:8

Prayer

Father, guide my husband's steps to walk in truth. Give him the courage to turn to right paths that lead *to* You and are led *by* You. May he be a man who learns to acclaim You and who walks in the light of Your presence (Psalm 89:15). I know You count blessed "the man who does not walk in the counsel of the wicked or stand in the way of sinners or sit in the seat of mockers" (Psalm 1:1). Today, convict and guide my husband away from any counsel that is not of You. Let him not take part in the activities of evil doers, but rather have the courage to walk away from temptations.

Lord, we know "He who walks with the wise grows wise" (Proverbs 13:20). Send my husband along paths that will lead to relationships that help him grow wiser, more humble, and stronger in You. Father, teach my husband to be a man who will do what You require of him: "to act justly and to love mercy and to walk humbly" before You (Micah 6:8).

Lord, Your command to walk in love is not grievous. Give my husband a heart that is gentle and loving to all he meets today, letting his love for You shine bright and true. May he walk honestly and humbly, having a clear vision of the path You would have him take. Bless him with clarity and courage when You instruct him in his paths. Father, You move the hearts of kings, so You will also move the heart of my husband to walk and lead rightly, surely, and lovingly.

Encourage him not only to walk in truth, but also to do so quickly. Teach him to seek Your guidance first and foremost, knowing You will never mislead. May my husband abide in Your tabernacle and dwell on Your holy hill as he walks uprightly and works righteousness and speaks truth in his heart (Psalm 15:1-2).

At the end of his long life, Father, may he look back and praising You, say, "I have kept my feet from every evil path so that I might obey Your word. I have not departed from Your laws, for You Yourself have taught me" (Psalm 119:101-102). I pray You will continue teaching him to understand Your precepts and that he will hate every wrong path.

Strengthen his resolve to seek wisdom from Your word: the very lamp to our feet and the light for our path (Psalm 119:105). May he always walk worthy of his calling, with all lowliness and gentleness, with long-suffering, and by bearing with all people in love (Ephesians 4:1-2). In Jesus' name, Amen.

Specific Prayer, Praises and Convictions

Fasting Challenge

Fast all beverages excluding water.

Record the beverages:

Other fasting choice:

Day 33

The Words He Speaks

Nothing reveals a person's heart faster than the words he or she speaks. Those little syllables coming out of our mouths have the power to harm or encourage, defile or bless, belittle or strengthen. God's Word advises us over and over to be mindful of what comes spewing out of our mouths.

James reminds us that if we do not keep a tight rein on our tongues, we deceive ourselves (James 1:26-27). Honestly, I'm not always the sweet, soft-spoken wife. There are times I feel more like a porcupine than a lady, and my words reflect those feelings well. However, displaying my grumpiness is evidence of the pollution of the world.

What is interesting about words is they set the tone for how people act and respond. When we shower those around us with ruthless language, we shouldn't expect to be honored or respected. When cussing comes out of our mouths, it spreads like a wild fire and soon spews from others around us. When anger, lies, rudeness, or any careless words are spoken, we heap poisonous ashes onto those who hear, suffocating the life and joy right out of them.

Don't do that to the hearts in your home.

Start right now by demanding clean, truthful, praiseworthy, respectful language from yourself. Set the tone for love to breed in your home. Ask the Lord to write His Word on the tablet of your heart. When we infuse our minds with His Word, what comes out of our mouths will reflect true beauty. Consider memorizing the following verses, or write them out on note cards and place them around your home as visual reminders to speak what is beneficial.

- "My dear brothers, take note of this: Everyone should be quick to listen, slow to speak and slow to become angry, for man's anger does not bring about the righteous life God desires." — James 1:19-20

- "Do not let unwholesome talk come out of your mouths, but only what is helpful for building others up according to their needs, that they may benefit those who listen." — Ephesians 4:29
- "She speaks with wisdom, and faithful instruction is on her tongue." — Proverbs 31:26
- "May the words of my mouth and the meditation of my heart be pleasing in Your sight, O Lord, my Rock and my Redeemer." — Psalm 19:14

Today pray that there would be a guard put on your mouth so that what you speak may be helpful and beneficial to your husband and family. Pray also that your example of washing your mouth clean would influence your husband to do the same, creating a home that is established on encouragement, nourishment, understanding, and acceptance.

Verses to Reflect Upon

"He who guards his mouth and his tongue keeps himself from calamity."

Proverbs 21:23

"Nor should there be obscenity, foolish talk or coarse joking, which are out of place, but rather thanksgiving."

Ephesians 5:4

"Avoid godless chatter, because those who indulge in it will become more and more ungodly."

2 Timothy 2:16

Proverbs 14:3

Ecclesiastes 10:12

Colossians 3:8

Colossians 4:6

Prayer

F ather, words are powerful. They carry life or death, blessing or curses, peace or dissension.

We know that out of the abundance of the heart the mouth speaks (Matthew 12:34). Make my husband's heart pure so that what comes out of his mouth is edifying to You. Do not let unwholesome talk come out of his mouth, but only what is helpful for building others up according to their needs (Ephesians 4:29).

Your Word has told us that there is more hope for a fool than a man who is hasty with his words (Proverbs 29:20). So when he feels like spewing anger or frustration, nudge his conscience and halt the words before they are uttered. Give him a gentle and patient spirit so that speaking kindly will become natural to him.

Grow the desire in him to think through his words before he speaks. I command away from his mind all negative thoughts that could result in unwholesome talk to others or about others. I take a stand against all evil spirits that encourage cussing, harsh words, uncaring words, or indifferent words. Give him the courage and strength to rid himself of anger, rage, malice, slander, and filthy language and to avoid godless chatter, knowing all those things will only lead to more ungodliness.

Instead of obscenity, foolish talk or coarse joking, convict him to speak in thanksgiving (Ephesians 5:4). Let his conversation always be full of grace, seasoned with salt, so he will always know how to answer everyone according to Your Word (Colossians 4:6). May the words of his mouth and the meditation of his heart be ever pleasing to You (Psalm 19:14). In Jesus' name, Amen.

Specific Prayer, Praises and Convictions

Fasting Challenge

Fast from all electronics.

Record them:

Other fasting choice:

Day 34

Covering His Choices

Choices: our days are filled with them. They are made either rationally or irrationally, with understanding or impatience. They display what is in our hearts and sadly, we are often swayed into making wrong choices depending on who we come into contact with.

But truly the problem lies deeper than that. The real reason we make questionable choices around questionable characters is because we are taking a haphazard stance in our faith. When we are rooted and grounded in Christ, we will be more concerned about what the Lord thinks of us than what others think.

I don't know what bad choices are hiding in your past. But, what I do know is that God doesn't intend for you to stay there. God has a history of using corrupt people to do mighty works for Him. Take the apostle Paul, for instance. He was one bad dude. By choice, he made it his mission to kill anyone who dared confess Christianity.

Then God knocked him up-side the spiritual head, and Saul, now Paul, did a complete one-eighty. He started spreading the gospel with the zeal he used to kill people with. Then he even died for his faith and saw it as an honor.

I wonder what Paul's former friends thought of him. I wonder if they came to visit him, and not knowing the change he made, started their normal ranting about those Jesus-followers. Maybe they even laid out a plan to go catch a few and murder them. Paul did not let guilt over his past choices or the people he used to call friends scare him way from being a truth-seeker, truth-sayer, and truth-doer. Paul stood firm. Refusing to be swayed for even a minute, he stood rooted and grounded in Christ even when it meant his former companions would now be hunting his skin.

The question remains: am I willing to go to Paul's extremes when making choices

between right and wrong? Who really dictates my choices? God or man? The Spirit or the flesh?

Maybe your husband is making choices that are not healthy for your marriage, your family, your future together, or his health. It's really hard to know how to respond well in these situations. Often, we try to take matters in our own hands when God doesn't show up fast enough to please us. Choose today to take your pain, concern, questions, and heartbreak to the One Who can do more in one day than you could in fifty years. Stop floundering in the seas of human tactics and mortal strength and let your sails be filled with the trustworthy winds of the Captain.

Now, I'll be the first to admit, sometimes prayer and fasting don't look or feel like they are accomplishing a whole lot. However, making the choice to unload that manure spreader full of life's undesirables onto God will accomplish far more than dragging it around myself. Who knows, He just might take that load of junk and use it to fertilize a land He has prepared for you in the future.

Those tears you are crying right now, He says He catches. Is it possible that as the Restorer of Broken Walls, He could be reserving those tears with plans to later water new growth in you, transforming your deserts into well-watered gardens?

I think, yes...because He's done it for me.

Today, ask God to invade specific choices you or your husband are making. Ask God to remove any worldly voices that clamor for your husband's attention and replace them with a clear knowledge of right and wrong. Ask the Lord to intervene and dictate your husband's choices, directing his life as He directs a stream. Then be ready to praise the Father for the mighty works you are about to see.

Verses to Reflect Upon

*"I have set before you life and death, blessings and curses.
Now choose life so that you and your children may live and that you may love the
Lord your God, listen to His voice and hold fast to Him."*

Deuteronomy 30:19-20

*"But if serving the Lord seems undesirable to you,
then choose for yourselves this day whom you will serve...
But as for me and my household, we will serve the Lord."*

Joshua 24:15

Proverbs 19:20-21

Proverbs 21:2-3

Prayer

Father, once again I praise You that You have given my husband the ability to make wise choices based on Your Word. You have said, "I have set before you life and death, blessings and curses. Now choose life so that you and your children may live, and that you may love the Lord your God, listen to Him and hold fast to Him" (Deuteronomy 30:19-20). Father, move my husband's heart to choose life and blessing every single day. Move him to choose Your instruction, knowledge, and wisdom instead of earthly riches and selfish gain (Proverbs 8:10).

Help my husband clearly see the way You would have him lead his family and live his life. May he boldly rise up and say, "as for me and my household, we will serve the Lord" (Joshua 24:15). Help him rise above present circumstances and see with an eternal perspective so he can make decisions based on Your will. If he makes a choice not glorifying to You, nudge his conscience to repentance.

All a man's ways seem right to him, but You, oh Lord, weigh the heart (Proverbs 21:2). Weigh my husband's heart and remove any offensive way in him that might hinder the choices he makes throughout his day. Keep his mind unobstructed when he is faced with decisions. Show him where he may be trusting too much in his own thinking rather than depending on You for guidance. Help him clearly confirm and accept the ways You want him to go.

Lord, I pray you will protect him from unhealthy pressures and expectations of this world that could drive him to make choices that ruin his mind, body, and soul. Direct his heart to say "no" to unhealthy relationships, harmful business deals, and selfish motivations. Supply him with wisdom so he may be kept in safety (Proverbs 28:26). In Jesus' precious name, Amen.

Specific Prayer, Praises and Convictions

Fasting Challenge

Fast from sugary
foods and drinks.

Record them:

Other fasting choice:

Day 35

Evaluating Friendships

It's true. We become who we regularly rub shoulders with. We may not intend to become like that group of women who have gossip sessions every week, nor would we intentionally speak disrespectfully of our husbands, yet it happens to the best of us.

We're sitting around the table over coffee, and soon the conversation drifts to something one of our husbands said or did that got under our skin. It might start out innocently enough with a funny story, but as unchecked conversations tend to do, the dialogue keeps being fed until we decide every man in our life needs to be set in his place for his apparent stupidity. Adding fuel to the frenzy, the enemy works our minds into a hot little mush over something that began as a simple mention of the dirty socks a husband dared leave on the floor.

Don't fall into the trap of gossiping about your husband. This will only bring tension and distrust into your marriage. In fact, one of the easiest ways to destroy your husband's trust is to run to your nearest friend with the latest misdeed he dared commit. Be the wife who is understanding toward her husband; the one who forgives quickly and overlooks his shortcomings. Don't be the contentious, dissatisfied, easily offended wife or his bones might start rotting (*wink!* Proverbs 12:4).

A man needs to know that it's okay to be human around his wife. His heart cannot safely trust in her if he is worried she'll demean or degrade him behind his back or in public. Ask yourself these questions about yourself and your friendships.

- *Are the conversations I have with my friends edifying to my marriage?*
- *Would I say this if my husband were here?*
- *Are my friends understanding and respectful of my marriage and our privacy?*
- *Are my friends respectful to their own husbands, and do they and protect the privacy of their marriages?*

If you answered "no" to any one of these, it's time to take a microscope to your friendships. Here is a good rule of thumb: If your dialogue with your friends includes talking about what a dunce your husband, or someone else's husband is, it's time to find new friends.

That might sound harsh, but which relationship is putting Christ and the Church on display? Your relationship with Susie or your covenant with your husband?

If any friendship could potentially harm or create unnecessary tension in your marriage, take steps to either end the friendship or ease away from it gradually. You might even be so brave as to ask your husband if your friendships ever make him feel discriminated against or second place. Make sure your husband knows you choose him above your friends.

Ask the Lord for wisdom and discernment in your evaluations of your friendships. Allow the Lord to impress on your heart any changes you may need to make in prioritizing your marriage. Pray that your example might be an encouragement to your husband, and that he might be moved to do the same evaluations of his friendships. Ask the Lord to replace unhealthy relationships in your husband's life with godly ones so that he may be further encouraged to invest in the health of your marriage.

Verses to Reflect Upon

"He who walks with the wise grows wise,
but a companion of fools suffers harm."

Proverbs 13:20

"Do not make friends with a hot-tempered man, do not associate with one easily
angered, or you may learn his way and get yourself ensnared."

Proverbs 22:24-25

Proverbs 12:26

Proverbs 16:28-29

Proverbs 20:19

1 Corinthians 15:33-34

Prayer

Dear Jesus, You are our one forever faithful Friend. You are the One Who sticks closer than a brother (Proverbs 18:24), but You did not intend a man to walk this earth alone or without friends in human flesh and form. You have encouraged us to walk with the good and the upright so that we might not grow weary in doing good or grow weak and complacent in our faith. So, Father, today I pray my husband will seek out friends who are wise and gentle. Give him friends who, as iron sharpens iron, will sharpen him (Proverbs 27:17), who will encourage him to keep on in the faith and do what is good, honorable, and respectable.

May my husband always be cautious in friendships (Proverbs 12:26), not choosing company that would lead him down a path that is evil (Proverbs 16:28-29). Father, I pray You would remove any interest he might have in pursuing the activities and ways of ungodly friends. Give him wisdom to see where he may need to discontinue any friendship that is not uplifting to his character. Do not let him make friends with a hot-tempered or easily angered person, lest he learn to do the same (Proverbs 22:24-25). Give him the knowledge to know he needs to avoid anyone who talks too much, for such a person is prone to gossip and is not trustworthy (Proverbs 20:19).

Father, I pray my husband would be a man who attracts godly friends. Remind him to listen before he speaks and walk in the humility it takes to put others before himself. Do not allow him to expect from others what he doesn't expect from himself. Encourage him to be a friend like Jesus, be a man of integrity, not easily swayed by men, and paying no attention to their rank or name (Mark 12:14), but treating each person with dignity and respect. In Jesus' name. Amen.

Specific Prayer, Praises and Convictions

Fasting Challenge

Fast all meats.

Record them:

Other fasting choice:

Day 36

Health of Body and Soul

Watching a loved one waste away from a disease is one of the most heart-wrenching things in life. On the other hand, seeing loved ones harm their bodies through careless addictions is almost maddening.

While our bodies are not meant to last forever, God still expects us to take care of ourselves as best we can with healthy eating habits, cleanliness, exercising, and by avoiding addictive substances or other unhealthy habits.

Being wise and disciplined in how we treat and use our bodies is important because God has told us we are not our own. We were created by Him, for Him and to Him. Our souls, once lost, were bought at the price of His Son's crucifixion. Our bodies, He tells us, are now a temple, the house where the Holy Spirit resides, dwells and meets with us. Therefore, it is very important that we honor Him with our bodies by how we nourish and care for ourselves.

While God is absolutely concerned about our physical health, He is more concerned about our spiritual health. His Word makes a few profound connections between the health of our bodies and the health of our souls. Proverbs 3:7-8 states, "Do not be wise in your own eyes; fear the Lord and shun evil. This will bring health to your body and nourishment to your bones."

Fearing the Lord and shunning evil means we desire to obey Him. Ephesians 4:22-24 instructs us to obey Him by putting off the selfish desires of our flesh, and putting on a new attitude of our minds, changing the way we think and the choices we make so that we might reflect God in true righteousness and holiness.

Retraining our minds to godly attitudes and thought processes takes time, effort, and continual refining. Much like a marathon runner strengthens his body little by little, so must we train our minds to think on things that are right and true in the

Lord. Just as the runner will maximize his training by changing his eating habits, so must we fuel our spiritual health with the food our Shepherd offers. To accommodate his training, the runner will also rearrange his schedule, making it a priority. So should we train ourselves in the Word of God by making it the most vital ingredient of our day so that we may have the perseverance to run the race marked out before us.

So "train yourself to be godly," 1 Timothy 4:7-8 says. For when we do, the Lord promises to bless us with health (Proverbs 3:7-8), prosperity (Proverbs 3:1-2), wealth, honor and life (Proverbs 22:4). Thus, we see that our spiritual health can dramatically impact our physical health and well-being. It is important to remember, however, that our spiritual health will not always determine our bodily health or finances. Nor will our physical struggles always reflect on our spiritual health. Our outer man will decay and our bank accounts offer no real security. It is godliness that will out-last it all and leave a legacy rich in spiritual health.

When praying for your husband's health, whether physical or spiritual, name specifics that the Spirit leads you to. He knows best what your husband is in need of, so let Him guide you in your prayer.

Verses to Reflect Upon

"Do not be wise in your own eyes; fear the Lord and shun evil. This will bring health to your body and nourishment to your bones."

Proverbs 3:7-8

"Do you not know that your body is a temple of the Holy Spirit, who is in you, whom you have received from God? You are not your own; you were bought with a price. Therefore honor God with your body."

1 Corinthians 6:19-20

"...offer your bodies as living sacrifices, holy and pleasing to God—this is your spiritual act of worship."

Romans 12:1

Proverbs 22:4

Ecclesiastes 12:13

3 John 1:2

Prayer

Father, You are the Healer who knows our bodies better than we do. Today, I pray that my husband's body will be kept in perfect harmony, working together and functioning the way You designed it to.

Father, help my husband take care of his body, for it is the temple where Your Spirit resides (1 Corinthians 3:16-17). I pray You would convict my husband to make healthy eating choices by not consuming anything that could harm or inhibit him from doing the work You have called him to do. Help him understand that he was bought at a price and he should honor You with his body (1 Corinthians 6:19-20). I pray he would not succumb to any food or substance addictions, but that in view of Your great mercy, offer his body as a living sacrifice, holy and pleasing to You (Romans 12:1).

Father, I pray also for his spiritual health. Urge him to obedience to Your Word, growing ever closer to You. Do not let him forget Your teaching, but convict him to store Your commands in his heart, for they will prolong his life and bring him prosperity (Proverbs 3:1-2). Let him not be wise as the world considers wise. I pray he will seek first to fear You and shun evil for that will bring health to his body and nourishment to his bones. (Proverbs 3:7-8) Give him wisdom and the knowledge to understand that his first and foremost duty on this earth is to obey You and glorify You (Ecclesiastes 12:13).

I pray that my husband may enjoy good health and that all may go well with him, even as his soul continues growing well (3 John 1:2). Then, at the end of his long, obedient and good life, I pray he may cross over into Your presence gently, easily, peacefully, and joyfully. In Jesus' name, Amen.

Specific Prayer, Praises and Convictions

Fasting Challenge

Fast all solid foods. Choose
broth, juices, and water.

Record them:

Other fasting choice:

Day 37

Healthy Emotions

Emotions are precarious things stewarded best by the One who gave them to us. There are many times in our days where we must choose how we will respond to things – for instance, that speedy little minivan that cut you off on the interstate. When our emotions take over, we might pound the steering wheel in frustration or blast our horn at them. The emotion of anger is one that is quickly displayed, often erupting without notice or plan.

Other emotions such as fear, depression, and sorrow are equally intense, yet some find these harder to identify or respond to properly. Society is especially hard on men regarding their feelings. They are taught at a very young age to "toughen up" and "be a man" because "real men don't cry". A scraped and scuffed up knee is met with a "Brush it off! You're fine". After all, scars are bragging rights, some claim. But the scars left by society's intolerance of emotional release in boys are real, causing them to become harder and harsher, stone facing anything that might threaten their tough exterior.

If your husband was taught to guard himself against showing emotions, or taught how to handle them incorrectly, it may take years to overcome those mindsets. But prayer is a powerful way to release him from those layers of tough leather, freeing him to express and feel without being ashamed.

Today, start praying for paths of victory to be laid for your husband in the area of his emotions. Ask the Father to give your husband the strength to respond appropriately, not turning to anger or panic when he starts to feel emotions like sorrow or pain. Pray also that your husband would feel safe and unashamed to express his deepest feelings around you, and that he might find a healthy place where he can express privately to the Lord.

Verses to Reflect Upon

"He who trusts in his own heart is a fool,
but he who walks in wisdom is kept safe."

Proverbs 28:26

"...bestow on them a crown of beauty instead of ashes, the oil of gladness instead
of mourning, and a garment of praise instead of a spirit of despair."

Isaiah 61:3

Psalm 30:1-3

Psalm 31:3-5

Prayer

Father, I pray You would instruct my husband regarding his emotions. Help him understand that it is okay to feel and express his emotions in healthy ways.

I pray You would demolish all strongholds, removing any diseases of the mind or unhealthy emotional behaviors like anger, depression, indifference, fear, hopelessness or suicidal thoughts. Deliver him from any negative ways of thinking. Help him not be anxious about anything, but in everything give thanks (Philippians 4:6-7). When he feels depressed, remind him to call upon Your name so that he may find peace and great joy in Your presence. Redeem his soul; spare him from sinking into the pits of despair (Psalm 30:3).

When my husband is frustrated, give him the wisdom and strength to control his words and actions. Do not let him be controlled by anger or fits of rage. Instead, renew in him a gentle, understanding spirit. I pray he would not be a jealous man who is always seeking but never finding, always wanting yet never content. Pour into his heart the emotions of thanksgiving and appreciation.

Father, free my husband from any shame he might have in showing sorrow, empathy, or any other emotions that others might not deem manly. Teach him also to enjoy lighter moments so he isn't always weighted down by seriousness. Father, anoint him with Your oil of gladness (Isaiah 61:3). Renew him, strengthen him, and empower him against any effects negative emotions bring. In Jesus' name, Amen.

Specific Prayer, Praises and Convictions

Fasting Challenge

Fast one meal.

Record the meal:

Other fasting choice:

Day 38

Overcoming Habits

When the Israelites disobeyed by failing to remove the vile images they had collected from Egypt, the Lord saw to it that they were severely punished. They spent forty years circling the desert, losing a whole generation before they were allowed to proceed to the promised land. The high cost of their choice to disobey brought indescribable pain upon themselves and all those around them.

Today our disobedience can still have a huge impact on those around us. Generational sin cycles are hard to break, but it only takes one obedient generation to set future generations free.

For example, Mandy's husband had been exposed to alcohol at a very young age. His father and his father before him lacked integrity, and the sin of addiction fell quickly into Daniel's life. Mandy watched for years as her husband struggled with breaking his dependence on alcohol. She knew this addiction had nothing to do with her not being a good wife, but it pained her immensely. The enemy tormented her repeatedly with doubts and anger. The heartbreak of her husband's flesh driven desire racked her small frame with sobs for many years.

However, Mandy also understood that there was a greater battle to be fought than with her husband. For thirty-seven years Mandy watched Daniel battle the grips of the drink. And every day she would faithfully get on her knees and plead the blood of Jesus over her husband.

Through Mandy's dedicated, relentless, fervent prayer and intersession, the Lord provided her husband with strength and obedience required to overcome the generational chains that held him captive. Today, Mandy and Daniel celebrate the Lord's faithfulness as they see their sons and grandsons all free from alcohol's poison.

Whatever our sin may be – unhealthy habits, detrimental thought processes,

stubborn mindsets, or addictions of any kind – our children are not exempt from their effects. In this way, we pass down to our children what we don't take care of. Pray for yourself and your husband to be enlightened to any habits that are harmful to both yourselves and your children. Naming specifics, ask the Lord to redeem you from these sins, completely breaking the chains of sin, enabling you to overcome any habits not glorifying to the Father.

Verses to Reflect Upon

"Don't you know that you yourselves are God's temple and that
God's Spirit lives in you? If anyone destroys God's temple, God will destroy him;
for God's temple is sacred, and you are that temple."

1 Corinthians 3:16

"I can do everything through Him who gives me strength."

Philippians 4:13

"...for a man is a slave to whatever has mastered him."

2 Peter 2:19

Psalm 19:13

1 John 2:15-17

Prayer

Father, You have sent Your Holy Spirit to live in us. Our bodies are a temple, a place for us to meet with You. I pray my husband will not let anything consume his body or mind that could destroy this temple, for You have said, he who destroys Your temple You will destroy also (1 Corinthians 3:16-17). I pray he will not be addicted to any harmful food or substance, nor participate in drunkenness or gluttony. I pray he will not be tempted to sin against his body by using or participating in pornography, sexual immorality, orgies, or the like. Keep his mind pure. Do not let him fall into the habitual ways of thinking that come from jealousy, anger, witchcraft, idolatry, or dissensions. Remove from my husband any tendency to gratify the flesh or seek self-satisfaction (Galatians 5:19-21). Do not let him be a man mastered by sinful desires (2 Peter 2:19). Instead, establish in him a clean heart with pure motives matched with the strength to stand against the enemy's temptations.

I stand humbly before You, Lord, asking that You keep my husband from any willful sin. Do not let him be ruled by his flesh (Psalm 19:13). Surround him with Your mighty protection. Lift him when he stumbles; carry him when he is weak. Strengthen him when he is tempted and convict him to persevere in what he knows is good, always growing into a greater faith. Remind him to be careful how he lives – not as unwise but as wise, making the best choice in every situation (Ephesians 5:15). After he has persevered, may he praise You, knowing he can do all things through Your Son who gives him strength (Philippians 4:13). In Jesus' precious name, Amen.

Specific Prayer, Praises and Convictions

Fasting Challenge

Fast all beverages excluding water.

Record the beverages:

Other fasting choice:

Day 39

Victory Over the Past

Our past lives can have an incredible hold on us and influence the way we see life and respond to its challenges. Issues stemming from our childhoods that were brought about by an absent father, a neglectful mother, or abusive family members alter the way we think about life and love. Breaking free from an unhealthy past can be a long, weary road.

Often times there are more recent happenings around work or friendships that grip at our hearts and take away our peace. Sometimes people take advantage of us or there are circumstances that we have no control over.

Whatever the case, unpacking any baggage from our trip through life thus far is not easy. The enemy would like for us to stay stuck in those dark places of the mind and soul, never maturing past the disappointments, anger, pain, and frustrations. The enemy would prefer to have us stay in those deserts of life, dehydrating our faith into extinction. But God longs to flood new hope and revived faith into those parched places. The Lord promises to make beauty from ashes. Our heavenly Father has a record of turning mourning into joy, and He is capable of providing peace when life makes no sense at all.

To be freed from our past we need to come to a place where staying the same is more painful than changing for the better. As much as we'd like to bury our wounds and pretend they never happened, our junk won't go away if we don't deal with it properly. Recognizing the issues helps us know how to better respond to what we are feeling. We must address our issues, repent from any sin, forgive where needed and trust the Father to give us strength for one more step.

Addressing our issues does not mean we brag about what we've done or how far we've gone. Verbalizing our pain and struggles is helpful to our healing process because it no longer keeps us isolated in fear or shame. Recognizing the past helps us grieve

what has been done to us or what we've done to pain the heart of God. Grieving brings healing. And if we don't grieve well, we can't heal whole. Being broken over our sin and shame makes for a pliable heart willing to be molded by the Potter, reshaped into His masterpiece.

Overcoming our history will also mean we need to know what God's Word says because the enemy will come and try to make us feel unworthy, insignificant, pathetic, and forever condemned. We mustn't fall for his lies, so we need to prepare ourselves with the truth of God's Word. We need to cast out the old habits, mindsets and past sin patterns and claim the new person that is created to be righteous and holy.

To enable us in the task of overcoming the past, the Father provides us the knowledge that He loves us and nothing can separate us from Him. He wants us to stand solidly on His promises so that we may have victory over our history. So know and hold onto the promises of God. Dig into His Word. Write them on the tablet of your heart. Be completely convinced of who you are in Christ.

If your husband struggles with his past, pray relentlessly against any grip the days of old may have over him. Name and rebuke any evil that might be trying to nibble at his heart, mind, and soul. Pray for opportunities to be opened for him to walk through that door of complete victory, set free and unchained.

Verses to Reflect Upon

"Do not say, 'Why were the old days better than these?'
For it is not wise to ask such questions."

Ecclesiastes 7:10

"Forgetting what is behind and straining toward what is ahead, I press on toward the goal to win the prize for which God has called me heavenward in Christ Jesus. All of us who are mature should take such a view of things."

Philippians 3:13-15

Isaiah 43:18-19

2 Corinthians 4:16-18

Prayer

Dear Jesus, thank You that You are able to set us free from all things past and present. You heal the broken-hearted and bind up their wounds (Proverbs 147:3). You have made a way for us to experience true freedom, and for that, I humbly thank You.

Bind up my husband's wounds, Jesus. Soothe his heart. Pour grace and mercy into him so that he may be able to forgive those who have hurt him. While it may be hard to forget what has been done to him, or what hasn't been done for him, I pray he would not lose heart but be strengthened day by day. Remind him that his troubles on earth are but momentary, so he may fix his eyes on You and cling tightly to Your great promises (2 Corinthians 4:16-18).

Father, You have told us to let go of former things and not dwell on the past (Isaiah 43:18-19). I pray my husband will not live in the past, or let it dictate him in any way. Instead, heighten his ability to do better for those coming after him than what was done for him. Strengthen him to stand against any generational sins that may be holding onto him. Help him see that You have a great and wonderful plan for him and You are calling him to set a new direction, a worthy heritage for his descendants.

Help my husband understand that You are capable of renewing all things, Father. That it is You who establishes a way through the desert and makes streams of life flow through wastelands of sin and pain. In Jesus' name, I stand against any powers and principalities of darkness that try to make him believe there is no hope. I lift my husband to You, trusting You to make him an overcomer. Though thousands would fall around him, in You he will remain unshaken.

Father, I pray that through my husband's complete deliverance, he would grow to find an appreciation for his past. May remembrances of his past serve only as reminders of Your great love and redeeming power, and result in praises to You for his healing and growth. May only peace, joy, thankfulness and greater faith come from the pains he has endured. Match and multiply the days of his gladness in proportion to his affliction (Psalm 90:15). In Jesus' name, Amen.

Specific Prayer, Praises and Convictions

Fasting Challenge

Fast from all electronics.

Record them:

Other fasting choice:

Day 40

Hope for the Future

Katie probably has no idea how her words impacted me then and even now, but as she reached for my hand, she said, "I can see in your eyes that you are hurting. Go to the Bible and underline every time it says God is your strength, God is your helper, your healer, your refuge and things like that." She finished up with three simple, yet profound words, "Then believe it."

Do you feel unloved today? Does the future look uncertain? Go to His Word. Do you need comfort today? There's plenty in His Word. Encouragement? His Word. Wisdom? It's there, in His Word. Faith? The Word.

Then believe Him for it.

Sit there and think on His promises. Mull over them, stir them up, dive into them—marinate in God's promises. Repeat those verses over and over, whisper them, say them out loud, shout them if you need to! Plaster them on your wall! Do whatever it takes. But don't you dare doubt them.

The enemy will come. He will try to squash whatever hope or renewed dedication you have. So this is the game plan: Hold up your Bible and read truth into whatever the enemy would have you doubt.

In order for us to stand against the wiles of the enemy we must to do as Paul told the Corinthian church, "Now, brothers, I want to remind you of the gospel I preached to you, which you have received and *on which you have taken your stand. By this gospel you are saved, if you hold firmly to the word*" (1 Corinthians 15:1-2 *emphasis mine*).

Paul's words encourage us to "take a stand" on the gospel. If we are to thrive here, we are going to need a bit of backbone. Something that says, *because I stand firm on the promises of God, I can get up and face whatever is coming my way.* We are going to need some salt in our soup, some spice in our cake, some conviction in our faith, and we

must start growing some spiritual meat on our bones. We're going to need to put our foot down, get our sass on, and lay claim to a few promises the Lord offers.

Let's be wives on fire for the Lord, willing to stand for truth. Someone who makes the enemy quiver at the thought of her belief. We mustn't be swayed by false teachings and the lies of the world. We must be alert and aware. May you and I balk against any schemes the enemy has to pry his way into our minds, our lives, our families, or our futures.

Now, sweet praying sister, before we part ways from this book, be encouraged that we have Jesus on our side. So lift your darling little chin and march head-on into your day, carrying your sword of truth and your shield of faith. And when you need to, *you use them.* Love more than you think you can. Be kinder than necessary. And pray bigger than you can dream. Then believe Him for it.

In Jesus' name, get your sass on!

Verses to Reflect Upon

"Whether it is favorable or unfavorable, we will obey the Lord our God, ...so that it may go well with us, for we will obey the Lord our God."

Jeremiah 42:6

Psalm 16:8

Psalm 25:4-5

Psalm 26:2-3

Psalm 27:4

Prayer

Father, thank You for this man You have set in my life. I pray you will give him a clear vision of what Your plan is for him. I pray that he will not pursue things of his own will but seek You first in all things, so he may lead his life in ways that are good, right, and beneficial to our marriage and our home.

Instruct him, Lord, in the way You would have him go. Stay at his right hand so he will not be shaken (Psalm 16:7). You have promised to give to each person that which he has done. I pray my husband will be a man who persistently seeks You in all he does and wherever He goes so that he may inherit eternal life (Romans 2:6-7).

Father, surround him with Your mighty wings, illuminate the path You would have him walk, and strengthen him to march courageously onward in obedience, whether the storm is favorable or unfavorable. I pray he would always be careful to live uprightly and act wisely, never letting an opportunity to bring glory to You go to waste (Ephesians 5:15-16).

Father, I lift my husband to You asking that You lead him in the way that is right so that it may go well with him, his marriage, and his descendants. In Jesus' precious name, Amen.

Specific Prayer, Praises and Convictions

Fasting Challenge

Fast from sugary
foods and drinks.

Record them:

Other fasting choice:

Final Word

I pray the past days have been a tremendous blessing to you, my friend. Not because of anything I wrote, but because the Spirit did a mighty work in you as you wrote out the Word, prayed Scripture, cried, grew and prayed again. May you find yourself enriched by His Word, fully grounded in His love, and better equipped to live out your calling as a wife.

It would be a tremendous blessing to me to connect with you beyond this book. You may do so through my website, www.kayleneyoder.com. There you will find more resources for women who are looking to encourage, deepen, and refresh their faith.

Love much! Pray big!

More from Kaylene Yoder

ABCs Scripture Cards for the Christian Marriage

Prayer Cards for Husbands and Wives

Prayer Challenges

R.E.S.T. Bible Study Method and Journals

and free printable resources can be found at:

http://kayleneyoder.com/books-resources-kaylene-yoder

Made in the USA
Coppell, TX
19 March 2024

30307133R10140